WYOMING
AIRMAIL PIONEERS

Starley Talbott & Michael E. Kassel
Foreword by Doniv Feltner

THE
History
PRESS

Published by The History Press
Charleston, SC
www.historypress.net

Front cover: Wyoming governor Nellie Tayloe Ross presided over a groundbreaking ceremony
for new hangars at the Cheyenne Airfield in 1925.

First published 2017

Manufactured in the United States

ISBN 9781625858641

Library of Congress Control Number: 2017934943

CONTENTS

FOREWORD

Cheyenne Approach, Skyhawk 2350Echo, 25 miles north, inbound with information Juliet.
 Skyhawk 2350Echo, Cheyenne Approach, Squawk 4202.
 Skyhawk 2350Echo squawking 4202
 Skyhawk 2350Echo, Cheyenne Approach, radar contact 24 miles north. Numerous thunderstorms in the vicinity. Say intentions.

"Say intentions"? What kind of a question is that? I'm going to try to stay out of these thunderstorms and hopefully land at the airport.

I had been fighting turbulence and dodging thunderstorms for an hour and a half all the way from Casper on this exceptionally hot and humid July afternoon. As I approached Cheyenne, the number of thunderstorms increased, and I was having difficulty maintaining legal cloud clearances flying the alleyways between storms.

Cheyenne Approach, Skyhawk 2350Echo, we're going to go west around this big build-up and approach from the west.
 Skyhawk 2350Echo, Cheyenne Approach, no other traffic observed in your area, report 5 miles west of Cheyenne.
 Skyhawk 2350Echo, roger.

After a short deviation to the west, I turned back inbound and made an uneventful landing at the Cheyenne airport.

Why did this flight, like so many of mine before, end safely and without incident? I had all the advantages of a modern, reliable, well-maintained aircraft; the assistance of air traffic control; GPS navigation; radio contact; radar vectors navigation; and very accurate weather information displayed on my iPad right in my aircraft.

The early airmail pilots of the 1920s had none of these advantages. They always flew with army surplus aircraft, no air traffic control, no navigational aids except written descriptions of various landmarks and little or no weather forecasts.

Starley Talbott and Michael Kassel accurately tell the story of the brave men and their flying machines. It begins with the reliability and endurance test of October 1919, continues through the establishment of the U.S. Post Office Airmail Service and concludes with contracting that service to private carriers in 1927.

They tell of the hardships endured and victories celebrated by the pilots, ground crews and support personnel of the original airmail service. When I fly and marvel at the beauty and magnificent vistas of the Rocky Mountains, I cannot help but think of what the early airmail pilots must have felt when faced with those giant obstacles along their routes. Flying at altitudes above ten thousand feet above sea level without the aid of oxygen systems or turbocharged engines was a challenge in itself—to say nothing of no weather radar, no air traffic control, no maps and no electronic navigation systems.

Imagine flying in an open-cockpit aircraft at night during a blizzard. How lonely must a pilot be flying over uncharted terrain with no one to talk to on the radio? What about crashing through trees and ending up in four feet of snow with no one knowing where you are and having to walk seventeen miles down a mountain to a ranch for help?

Why would anyone want to do these things? Perhaps for the glory, respect or admiration of their fellow pilots? Maybe for all of these reasons or none of them. Whatever the reason, these brave pilots endured hardships that are totally foreign to us modern pilots. They established routes and procedures for flying in the Rocky Mountains that are still in place today.

Mechanical failure of the aircraft was common but rarely resulted in a fatality, as the pilots were very skilled in landing off airport. Weather, on the other hand, caused most of the lost lives when they were unable to see the obstacles ahead or their aircraft iced up. Slim Lewis landed four times between Scotts Bluff, Nebraska and Cheyenne, Wyoming, because his carburetor continued to ice up. He would thaw it out and take off again.

On the fourth landing, he was unable to clear the ice from his carburetor, so he borrowed a team of horses and a wagon and drove the last four miles to Cheyenne. This is just one of many examples of the dedication of the pilots to get the mail through.

Elrey Jeppesen kept extensive notes of each airport and the best routes into them and established the extremely reliable instrument approach system that we still use today to land in bad weather.

Many of the pilots used the experience they learned and went on to become test pilots for the military and Boeing Aircraft Company. Still more became pilots for the newly emerging airline industry. They were the pioneers who paved the way to make modern aviation the safe and reliable system of transportation it is today.

Come join Starley Talbott and Michael Kassel while they tell the story of the political battles to establish the airmail service, the challenges of testing it and the victories celebrated with the building of each new airport and hangar facility.

You will recognize many of the names, places and events revealed in this book, as they are an unforgettable part of our history. They not only made a great impact on our aviation transportation system but also shaped our cities as they grew up around the airports. Every industry benefited from this new method of rapid movement of information and eventually goods. The mail was moved from New York to San Francisco in as little as thirty-nine hours.

I have been involved in aviation in the Rocky Mountain region for more than forty-five years as a mechanic, pilot, flight instructor and pilot examiner. In that time, I have written, reviewed and read many books and articles about aviation in this area. Starley Talbott and Michael Kassel have captured an accurate and detailed account of the history of the airmail service and show the very roots of the safe and efficient aviation system that we enjoy while flying the Great Plains and Rocky Mountains today.

—Doniv Feltner

Doniv Feltner is an aviation mechanic, pilot, flight instructor and pilot examiner. He served in the United States Air Force and the Wyoming Air National Guard. He has been involved in aviation in the Rocky Mountain region for more than forty-five years. Doniv is the chief instructor and president of Wings of Wyoming flight school.

ACKNOWLEDGEMENTS

The authors are grateful for the many people who made the compilation of this book a reality. Without the bravery of the early pilots, there would be no story, and without the writing, research and assistance of many historians, we could not have written this narrative.

Special thanks go to the staff and volunteers at the Wyoming State Archives, especially Suzi Taylor, Cindy Brown and Larry Brown. Their ability to locate materials related to aviation is remarkable.

We appreciate the efforts of many people who provided information from personal collections, with a special thank-you to Jack Tefft for the loan of his extensive aviation collection. We thank Doniv Feltner of Wings of Wyoming Aviation School for providing Michael Kassel with the opportunity to fly the historic airmail route between Cheyenne and Laramie, as well as pilot Thomas Hutchings for guiding the flight. Special appreciation goes to Steve Wolff, a former C-130 pilot for the Wyoming National Guard, for his extensive research of the markers and signal lamps that still stand as sentinels on the plains marking the grand Transcontinental Air Mail Route. We thank the Medicine Bow Museum staff for their guidance in researching remnants of their historic airmail field.

We give special thanks to our acquisitions editor, Artie Crisp; our project editor, Ryan Finn; and others at The History Press for their support and guidance.

Most importantly, we are grateful for our families and our spouses. Michael thanks his wife, Amy, who has been the wind beneath his wings

blessing him with her encouragement and fortitude. Starley thanks her husband, Beauford Thompson, for his support in so many ways, including being the first reader of her manuscript. Starley thanks her coauthor, Michael Kassel, for his important research on the subject and for his speaking ability, which first inspired her to delve further into the fascinating history of the airmail pioneers.

Lastly, we thank our readers and the many people who continue to inspire us with a love of history.

INTRODUCTION

The ability to communicate has long been a cherished attribute for human beings. Messages have been exchanged by different means of transportation throughout history.

Mail was carried by ships from the East to West Coasts around the tip of South America during the early years of American settlement. Soon after the American West was settled in the mid- to late 1800s, mail and cargo were shipped overland by stagecoach and carried by wagon trains traversing historic trails. A faster method was desired and made possible in 1860 by Pony Express riders, who were able to deliver mail from St. Joseph, Missouri, to San Francisco, California, in ten days. The Pony Express was soon deemed obsolete by the 1861 invention of the telegraph, which could send wireless messages in a matter of minutes.

Although the telegraph remained a valuable asset for sending short messages, other means of delivering packages and letters were necessary. By the completion of the transcontinental railroad in 1869, the era of nationwide mail delivery by train was established, even though mail had been transported by train on the East Coast much earlier.

The builders of the Union Pacific Railroad had sought the easiest grade to pass through the Rocky Mountains and found that path through southern Wyoming. The route was also chosen because it formed a nearly straight line between Omaha and San Francisco and had the added benefit of being close to the mineral wealth of Colorado. Cheyenne, Wyoming, was a major station on the railroad's route and was located at the foot of the lowest point across the Continental Divide.

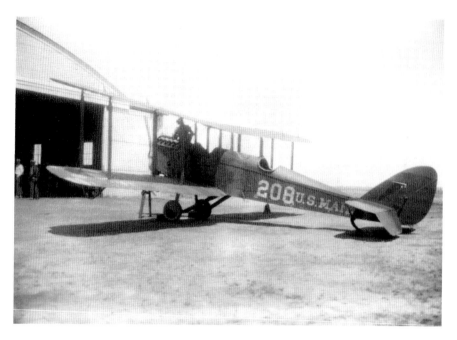

U.S. Post Office Air Mail Plane no. 208. *Wyoming State Archives, Department of State Parks and Cultural Resources.*

When the idea for a transcontinental airmail route was conceived, Cheyenne was considered as a natural division point for the airmail service. The city was chosen as a major station on the airmail path for many of the same reasons that were deemed desirable by the builders of the railroad.

The plan for a transcontinental airmail service was considered difficult if not impossible by many. It had been proven that it was possible to fly airplanes across the continent when the U.S. Army Air Service conducted a Transcontinental Reliability Test. One object of the air race was to demonstrate advances in aeronautical technology that could be used for peacetime purposes following World War I. However, Brigadier General William "Billy" Mitchell wanted to prove that defending the country by air was possible and that an independent air force was necessary. He wanted to garner support from the public to convince Congress to appropriate funds for such an endeavor.

The Transcontinental Reliability Test was fraught with problems, delays and the death of several pilots. However, the test did prove that airplanes could fly across the continent and provided a basis for the concept of a transcontinental airmail service. Otto Praeger, assistant postmaster, declared

that the race had demonstrated the practicality of transcontinental airmail service, and he pressed for the adoption of such a route.

Airmail service nationwide was gradually adopted after early routes were established on the East Coast. The first itinerary between New York and Washington, D.C., of 218 miles provided one round trip daily beginning on May 15, 1918. Other routes were added, with three in operation during 1919, when daily mail service included eight planes flying about 1,900 miles each day. On May 15, 1920, the leg of the transcontinental route from Chicago to Omaha was established. The last leg of the transcontinental route from Omaha to San Francisco via North Platte, Cheyenne, Rawlins, Rock Springs, Salt Lake City, Elko and Reno was established on September 8, 1920.

The United States military provided airmail service in the beginning. The United States Post Office took over the operations in 1918 and continued to operate the airmail service until 1927, when it transferred airmail delivery to commercial airlines.

Airmail pilots were daredevil types willing to take risks to be part of this new American adventure. There were no early flight maps, and directions were compiled by pilots and station managers. Pilots navigated by searching for landmarks. Initially, the mail was flown only during daylight and was transferred to trains at night to be delivered to the next leg of a flight. Regular nighttime airmail service began in 1924, when beacons were installed at all mail fields and marking lights were placed at emergency landing strips. A variety of aircraft was also used during the first years of airmail service. The new but glamorous service of delivering the mail via the sky was a dangerous undertaking, and during the nine years of the early service, thirty-two pilots lost their lives.

The focus of this book is to present the history of the routes and the pilots for the western leg of the airmail service from Chicago to San Francisco, with emphasis on the base in Cheyenne, Wyoming, and the stories of the pilots who operated through that location.

Chapter I

THE TRANSCONTINENTAL RELIABILITY
AND ENDURANCE TEST

October 1919 was the pivotal point for the establishment of a transcontinental air route in the United States. Colonel Billy Mitchell of the U.S. Army Air Service spearheaded the Transcontinental Reliability and Endurance Test to examine the reliability of existing army aircraft. Mitchell was primarily concerned with proving the concept of aircraft being able to fly across the continent to protect the United States from invasion. He also wanted to garner support for his idea of establishing an air force unit separate from the U.S. Army Air Service. Mitchell had been stationed at Fort D.A. Russell in Cheyenne, Wyoming, with the Signal Corps in 1910, and he served in World War I.

Previously, aviators had flown across the United States, but the transcontinental trip was considered a hazardous undertaking. A route was selected that ran from New York to Buffalo and then to Cleveland, Chicago and Omaha. Aviators planned to follow the tracks of the Union Pacific Railroad beginning at Omaha and continuing to San Francisco via Cheyenne, Salt Lake City, Reno and Sacramento. The railroad route followed favorable terrain, supplies and equipment could be easily available and the tracks, known as the "iron compass," would serve as the primary navigational tool from Omaha to San Francisco.

Twenty refueling stations were planned for the 2,701-mile route. Contest rules called for a minimum stop of thirty minutes at each point, and flying was restricted to daylight hours. The route had originally been planned as a one-way crossing, with flights originating on both the East and West Coasts.

Organizers, however, realized that prevailing westerly winds would provide an advantage to those crossing from the west to the east, so the contest was changed to a round-trip race.

Cheyenne, Wyoming, provided an ideal location on the transcontinental route because it was located at the base of the highest crossing point along the way, Sherman Summit, at 8,200 feet. The city was chosen as a control point for the race where fuel, motor oil, tools and spare parts were available, as well as for the ability to assist in making possible repairs. The first of fifty-seven different types of aircraft was scheduled to arrive in Cheyenne on October 11, after beginning the race three days earlier. Each pilot would have official records of the time of arrival and inspection of his or her logbooks for accuracy and details upon arrival at the Cheyenne site.[1]

Community leaders in Cheyenne participated by manning a canteen and providing first aid and timekeepers for the race. The importance of the race for Cheyenne's future in aviation arrived with a letter from the United States War Department stating the significance of the transcontinental test for the development of the New York–San Francisco air route.

The first day of the race began rather ominously when Colonel Gerald Brandt crashed his aircraft upon leaving Mineola, New York. He broke his arms and legs and suffered internal injuries. However, planes from both east and west reached their destinations on the first day of the race.[2]

The first plane to arrive in Cheyenne was eastbound Captain Smith flying a British de Havilland Bluebird with a record time for flying from Salt Lake City to Cheyenne of four hours and four minutes. Four pilots had actually left Salt Lake City at the same time but had been separated while flying through snowstorms with very high winds. Two other pilots arrived in Cheyenne, but a fourth plane was forced to land at Green River and was out of the race.

Westbound planes also experienced bad weather, causing two of them to be ditched in the Great Lakes. Others were forced down by storms, and one crashed nose-down in the mud upon landing.

A total of three fliers were killed and one injured in eight different accidents on the first day of the race from both east- and westbound flights. However, the race continued and provided additional drama in the days to come. The *Wyoming State Tribune* reported that local interest was very keen, as Cheyenne residents speculated on when the next planes were to arrive in the city. The editors of the newspaper predicted that the interest in the transcontinental race was going to overshadow the upcoming World Series.[3]

On the morning of October 10, several planes arrived in Cheyenne, making a total of six flights from the West arriving that day. Lieutenant

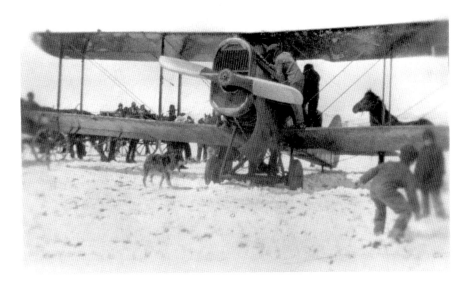

Curious onlookers examine a plane during the 1919 Transcontinental Air Reliability Test at Fort D.A. Russell near Cheyenne, Wyoming. The crowds on the field, including children, show great interest in the DH-4 plane, the most successful aircraft to participate in the test. *Wyoming State Archives, Department of State Parks and Cultural Resources.*

Queen was the first to fly one of the many DH-4 planes into the city. After he refueled and departed, Major John Barthol arrived and took off again.

Wyoming's first aviation fatality occurred that same day when a plane crashed near Elk Mountain, Wyoming, killing pilot Edward V. Wales. The flying partner for Wales, Lieutenant William Goldsborough, described the tragedy:

> *We were flying in an air line route from Rawlins to Cheyenne. We were flying high and encountered some clouds. Lieutenant Wales brought the machine down, so that we were proceeding below the clouds. There was a terrific snow storm, and no visibility, so we slowed up and were flying low. The ground was rising and we rose slowly to maintain an even height. We were south of the peak called Elk Mountain. We struck a pass, and were doing well when all of a sudden the side of the hill confronted us. Lt. Wales turned the machine sharply to avoid hitting this, it went into a tail spin and dropped into the ravine. I was knocked out, but came to in a few minutes and got Wales out. He was badly cut and*

bleeding profusely. I got the bleeding stopped with the means available, then wrapped him in all the clothes we had, built a fire alongside of him and went to the Paulson ranch for help.

Goldsborough was bruised and shaken when he arrived in Cheyenne after seeking help at the ranch near Elk Mountain. Unfortunately, Edward Wales did not survive. A team of army personnel traveled to the crash site a few days later to salvage the 2,800-pound aircraft. They struggled through snow and rolled the engine down the mountainside to a waiting truck.[4]

Later in the day, the first plane arrived in Cheyenne from the East with a broken radiator. For several hours, the pilot, Lieutenant Belvin Maynard, waited at Fort D.A. Russell (a military base at Cheyenne, now F.E. Warren Air Force Base) as ground crews worked to repair his plane. Maynard lamented, "It was a nice day down in Chicago when we left, but it was freezing cold in Cheyenne."

Maynard was finally able to continue his flight and claimed victory on the first part of the transcontinental reliability test. He flew the 2,625 miles of the race at an average of 109.5 miles per hour in twenty-four hours, fifty-nine minutes and forty-eight and a half seconds of actual flying time. On October 15, Lieutenant Maynard was on his return leg to the East Coast, landing in Cheyenne on October 16. He and his mechanic, Sergeant William E. Kline, and Maynard's dog, Trixie, paused for a meal at the Red Cross canteen before taking off again. They landed that night on a snow-covered field at Sidney, Nebraska, continuing the race the next day. On October 18, 1919, the drama of the race for first place concluded when Lieutenant Maynard was the first to land at Mineola at 1:00 p.m.[5]

Onlookers in Cheyenne were to witness many interesting sights, as several planes had landed during those early days of October. Lieutenant Colonel Thomas S. Bowen landed his badly mauled aircraft and told the curious crowd that as he was flying over Indiana, he was forced to land in a farm field. The field was filled with hogs, which sauntered over to the plane and began to eat the canvas from the plane's tail. After a patching job, the lieutenant was able to continue on to Cheyenne.[6]

Other mishaps along the way included what happened to the plane of Lieutenant J.B. Wright and Sergeant V. Coleman, who landed at Sterling, Colorado, instead of Cheyenne. The two men had followed the wrong branch of the Union Pacific Railroad and upon landing had hit a fencepost and barely missed telephone wires. They made repairs and continued the race.

October 17 was the busiest single day during the race at Cheyenne. A dozen planes landed at the field, with two others making spectacular crashes. One plane ended upside down, crushing both wings and the fuselage but with no human injuries. The second plane folded in half upon impact, resulting in a destroyed propeller, a smashed landing gear and torn wings. The accompanying flight engineer slid down the tail of the plane and was thrown forty feet into the air, landing with only a few bruises.[7]

Seven other pilots completed the round-trip crossing of the continent before the U.S. Air Service declared the contest finished on October 31. Mitchell's dream of securing funding for the air service and establishing a separate air force unit may have been in doubt when members of the press and Congress deemed the air race a failure. They believed that the air race had demonstrated that unreliable aircraft, inadequate navigational instruments and primitive landing facilities did not support the establishment of a transcontinental air route.

However, the attitude of officials in Wyoming differed from those of the national press. They believed the test had proved that organized flight operations were possible for an extended period and that the selected route was an ideal way through the Rocky Mountains. A prophetic gesture was made when letters from Wyoming senator Frances E. Warren and Representative Frank M. Mondell arrived on one of the planes taking part in the Transcontinental Reliability Test. Senator Warren "expressed

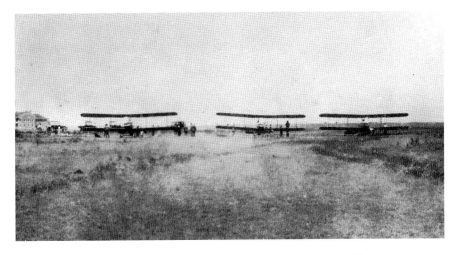

Three Curtiss JN-4 "Jenny" aircraft at the Fort D.A. Russell airfield in Cheyenne, Wyoming, circa 1920. The airmail service had planned to use the field at the fort but was later denied its use by the government, citing its likely need for military activities. *Michael E. Kassel Collection.*

gratification over the fact that the capital city of Wyoming has long enjoyed the distinction of being located on the main line of the Lincoln Highway, over which so much surface transportation goes, and that now it is to become a control station in the cross-country air routes." For his part, Representative Mondell wrote, "The flight emphasizes the increasing importance of the ships of the air and the annihilation of distance." He also said that he hoped that the new developments would allow congressmen to get home more frequently.[8]

Postal officials, especially Assistant Postmaster Otto Praeger, had hoped that the race would also help to establish the possibility of the post office operating a transcontinental airmail service. Praeger argued that the air race had demonstrated the practicality of cross-country airmail service. He would not give up his dream for the establishment of such a service and predicted that it would be able to begin operation by 1920.

Chapter 2

THE UNITED STATES AIR MAIL SERVICE

The United States assistant postmaster general, Otto Praeger, was a strong advocate for establishing airmail service. Praeger had developed the first automotive branch of the United States Post Office in 1914 by establishing routes where the mail was delivered by trucks over short intercity distances and over longer distances by trains and boats.

Praeger was convinced that if a system could be developed to provide coast-to-coast mail delivery via flight, it would be much faster than delivery by train. His efforts became known as "Praeger's Folly," although he was able to convince the Unites States Congress to provide some funding for the project.

Cities along the proposed airmail route were eager to provide suitable facilities for the new service. Cheyenne, Wyoming, was particularly happy to accommodate the effort and planned to operate a facility daily with a support staff of fifteen to twenty personnel permanently based in Cheyenne. The city agreed to provide the cost of building hangars for the airplanes. The *Wyoming State Tribune* on May 9, 1920, stated that "Cheyenne will be the hub of the mail service for western Nebraska, Wyoming, Colorado, New Mexico, Montana and the western part of the Dakotas." Cheyenne's assets included its designation as the state capital, good level terrain suitable for airplanes to land close to the city, a location midway between Omaha and Salt Lake City, the east–west Union Pacific Railroad and the transcontinental Lincoln Highway (U.S. 30/I-80) running through town.[9]

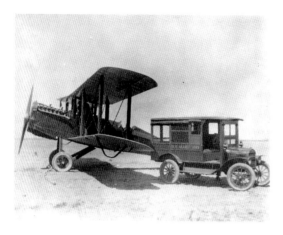

Airmail plane and mail truck,
a symbol of the newly minted
transcontinental airmail service.
Smithsonian National Postal Museum.

Cheyenne began expansion of the facilities for the airmail service during the summer of 1920. The airfield was to be established at Fort D.A. Russell, and three hangars were to be constructed complete with lighting, telephones and water and gasoline services. However, plans were interrupted in late July. A letter from the secretary of war noted a refusal to share the military airfield at Fort D.A. Russell with private aviation concerns, as it was believed that in the event of hostilities, the field would be needed solely for military work.

The City of Cheyenne decided to turn over a two-hundred-acre plot of flat prairie land it owned about one mile north of downtown for use by the United States Air Mail Service. Support was given to the city by Laramie County and the Cheyenne Chamber of Commerce to erect a four-plane hangar of steel and concrete for the mail planes, a guardhouse, an oil house, a workshop and a steam heating plant—all of which needed to be ready by September 1, 1920.[10]

In late July 1920, the airmail service sent a pathfinder team over the proposed route to report on the acceptability of the transcontinental route and selected stations. The pathfinder team landed in Cheyenne to inspect the new airfield and declared it acceptable.

The Wyoming Division superintendent of the airmail was to be stationed in a small building just to the south of the hangar on Cheyenne's new airfield. The post office also advertised that that it was looking for applications for pilots and mechanics. By mid-August, several airmail planes were flown to Cheyenne in preparation for the new airmail service. A large shipment of tools, supplies and even wings arrived from the East Coast. The stage was then set for the launch of the longest overland air route in the world.[11]

Other cities in Wyoming were also anxious to provide facilities for the new airmail service. The *Rock Springs Miner* newspaper in Rock Springs featured this headline on page one of the August 13, 1920 edition: "Rock Springs an Important Stopping Point on the Trans Continental Aerial Mail Route—Division Superintendent of Route Visits City and Pronounces Landing Field One of the Best in the West—Service to Begin First Week in September, an 80 x 90 Hangar to Be Erected and Mechanics Employed."

The Rock Springs newspaper went on to report that Andrew R. Demphy, division superintendent of the Aerial Mail Service, had recently arrived in the city and inspected the new landing field north of the city. He pronounced the Rock Springs facility "one of the best in the entire western country." Mr. Demphy was assured by city officials that everything would be ready for the opening of the service, and he wired the post office department concerning his selection of the Rock Springs landing field. The mayor of the city received the following telegram in response:

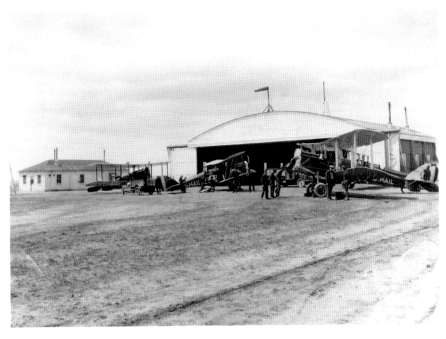

Hangars and airplanes, Cheyenne, Wyoming, circa 1922. *Wyoming State Archives, Department of State Parks and Cultural Resources.*

P.O. Dept., Washington D.C., Aug. 11, 1920. J.B. Young, Mayor, City of Rock Springs, Wyo. Post Office Department accepts arrangements made by City of Rock Springs in Sweetwater County, for landing field and hangar, light, telephone, gas tank for air service, made with A.R. Demphy, Div. Supt. Air Mail Service. Blank forms of agreement same as North Platte, Reno, etc., going forward by mail, please fill blanks and execute in triplicate for your own, and our files. Probably have to make Rock Springs over night stop air mail, therefore essential to have hangar completed if possible, for opening first week in September. Praeger, Second Asst. P.M. Genl. [12]*

The *Rock Springs Miner* reported again on August 27, 1920:

The first planes of the Aerial Mail line from New York to San Francisco landed at the new Rock Springs field at 1:25 on Thursday afternoon and remained on the field for about four hours. During their time here they were supplied with gas, oil and water and several repairs were made to one of the engines. The planes were two DeHavilands [sic] *and are the first of five planes on the route to San Francisco. Several hours before their arrival hundreds of people were at the landing field and on the hills looking toward the east, and when the two planes had come safely to rest on the field they were the objects of much curiosity. In their curiosity over the arrival of the planes on Thursday, a number of persons did not heed the request of those in charge of the field. A number of cars were driven over the field, causing deep ruts in some places. Cars were strung out along the road way across the entire side of the field, making it uncertain for the aviators to properly time their landings. In the future it is stated, no cars will be allowed on the field, or along that part of the road adjoining the field. All cars must be kept a sufficient distance to allow a clear and unobstructed view.* [13]

By September, the excitement in Wyoming was coming to fruition as the first official airmail flights were at hand. On September 8, 1920, pilot Buck Heffron took off from the Cheyenne airmail field with four hundred pounds of mail and set off for Salt Lake City. The next day, September 9, the first airmail from the East arrived when James P. "Jimmy" Murray landed his plane after having been delayed by engine trouble. Murray was soon able to continue his flight without further incident. He returned to Cheyenne with the first eastbound mail on

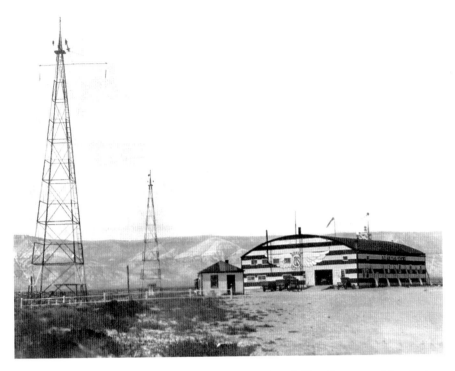

The airmail field at Rock Springs, Wyoming. *Wyoming State Archives, Department of State Parks and Cultural Resources.*

September 13. He had completed the first operational cycle of the first permanent aviation endeavor in the Rocky Mountains. Cheyenne had leaped ahead in national aviation significance, a position that it would retain for the next twenty-seven years.[14]

In Rock Springs, the drama continued to unfold, as reported by the *Rock Springs Miner* on September 10, 1920: "During the past week the people of Rock Springs have realized that this city is on the transcontinental aerial mail line. Seven planes have so far stopped here in the past six days, some of them remaining to undergo repairs, but others merely stopping for supplies and minor repairs and then continuing their journey to the west."

Many aviators were attempting to set new records for crossing the country. America's most renowned World War I ace, Captain Eddie Rickenbacker, who had unsuccessfully attempted a landing in Cheyenne on an earlier flight, finally made it to Cheyenne in May 1921. Rickenbacker was on a west–east flight aimed at setting a new coast-to-

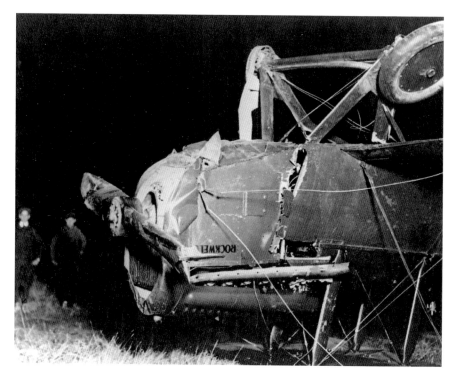

Eddie Rickenbacker crashed his plane at Fort D.A. Russell near Cheyenne, Wyoming, on May 26, 1921, ending his hopes of establishing a world speed record at that time. *Wyoming State Archives, Department of State Parks and Cultural Resources.*

coast speed record. Arriving after dark, with lighted oil drums to mark the landing area at Fort D.A. Russell, Rickenbacker landed downfield, hit the Old Deadwood stage road on the east side of the airfield during the landing and flipped upside down. Rickenbacker escaped unhurt, but his plane was damaged beyond quick repair, and his attempt to set the speed record ended in disappointment in Cheyenne.[15]

The reputation of the pilots who worked for the United States Air Mail Service established these men as folk heroes shortly after the initial initiation of the service on the East Coast in 1918. The early history of the airmail is largely a history of the pilots since, to a great extent, they dominated the entire picture.

A dashing new folk hero in Wyoming's skies was the subject of a poem printed in the July 25, 1920 edition of the *Denver Post*, evoking the legend of the airmail pilots:

THE AIRPLANE MAIL
By C. Wiles Hallock

O, Mr. Birdman, can you see
As through the sky you go
The little earth and little me
So far, so far below?

And if you see me, winging by
So far, so far above
Will you send down word as you fly
A letter from my love?

And will you hasten back again
And notify by Sweet
You dropped his letter from your plane
Here at my very feet?

O, Mr. Birdman, do you know
How very near to me
You're bringing, winging to and fro,
The one so dear to me?[16]

Chapter 3

PILOT'S DIRECTIONS

I n the early days of the airmail service, pilots had no official maps of the routes to guide them on their flights. The post office provided information in a guide named *Transcontinental Air Mail: Pilot's Log of Distances, Landmarks, and Flying Directions*. The introduction to the guide noted, "These flying directions and the ground information were prepared with the cooperation of pilots and supervisory officials of the Air Mail Service and with the assistance of the postmaster located within 5 miles of the line of flight. All employees of the Air Mail Service will be required to familiarize themselves with the information relating to the section of the route with which they are concerned." It was signed by Second Assistant Postmaster General Otto Praeger, Washington, D.C., February 20, 1921.

All pilots were also required to swear to the "Oaths of Office," including swearing to faithfully perform all the duties required, abstain from everything forbidden by the laws of the post office and account for any money belonging to the United States. They further swore to fly whenever called on and in whatever airmail plane was directed by the superintendent of their division. Refusal was considered to be cause for a pilot's resignation from the service. This rule contributed to the pilot's belief in what was called Otto Praeger's "fly or be fired" policy.

The document also included "General Aims, Conduct and General Rules" for pilots:

GENERAL AIMS:

(a) *The most important duty of all pilots, first, last, and always is to get the mail entrusted to him to its destination on schedule time.*

CONDUCT:

(a) *All pilots should so conduct themselves as to be in the finest condition both mentally and physically, both for self-protection and for the protection of the valuable property assigned to them.*

(b) *As a pilot in the Air Mail Service, you represent the Post Office Department, and as such a representative you will be courteous, and will act the part of a gentleman at all times.*

(c) *A part of the pilot's rating will be based on the promptness with which he reports for the various duties assigned him.*

(d) *Pilots will obey all orders from the Second Assistant Postmaster General, Superintendent of Operation or Chief of Flying through the division superintendent to whom they are assigned, promptly, or suitable disciplinary action will follow.*

GENERAL RULES FOR PILOTS:

(1) *Pilots shall not perform stunts with mail airplanes, nor put them to unnecessary strains in service.*

(2) *Pilots shall not carry passengers in mail airplanes except by authority of the Second Assistant Postmaster General or the Superintendent of Operations.*

(3) *Under no circumstances will the weight of mail be reduced to take on a passenger unless by specific order of the superintendent.*

(4) *When proper authority has been granted for passengers to be carried on a mail trip, the representative at the starting point should place his o.k. on the letter authorizing flight, and when the destination is reached by the aviator and passenger, the passenger will then affix his signature on the letter of authorization and the representative will then forward it to the Division of Air Mail Service for the files.*

(5) *Pilots are expected to report at the flying field early enough to make reasonable inspections of the ships they are to fly, and to assure themselves that the motors are being properly warmed up.*

(6) *Pilots shall see that emergency tool kits are placed in the airplanes and will be responsible for their absence, unless they have made complaint to the manager before departure. (Get plane inspection card from manager.)*

(7) Pilots shall fly at safe altitudes, weather permitting. As the safe altitude varies with the character of the country and the type of the airplane flown, no altitude can be here specified.

(8) Maps shall be carried, unless the pilots are absolutely certain of the routes.

(9) Pilots must observe compasses, even when not flying by compass, as the compass very easily gets out of adjustment, and cannot be kept accurate without constant observation and recompensation. Pilots are therefore directed to check up course and compass on each flight and report compass readings and approximate deviation.

(10) Pilots landing with mail have the right of way.

(11) In making out pilot's reports, pilots will carefully set down all the information requested and such other information, regarding the condition of the airplane, motor, or weather, as they deem important or helpful.

(12) The Air Mail service is run on schedule. Pilots will therefore report, on the "Pilots Report" card, the cause of any delay in starting in excess of ten minutes.

(13) Pilots shall make every effort to arrive on schedule time. This means that the motor must be pushed against a headwind.

(14) Pilots will locate likely fields at every opportunity, reporting location and description to the division headquarters.

(15) Each pilot will familiarize himself at once with all characteristics of all flying fields which he must use in line of duty. No excuse will be accepted for "crashing" a ship on a home field when it is evident that pilot "crashed" through lack of knowledge of local conditions.

(16) On account of the fact that the varying conditions at the various fields prevent drawing up a standard set of field rules, pilots shall familiarize themselves with the local field rules obtaining at each station and be guided accordingly.

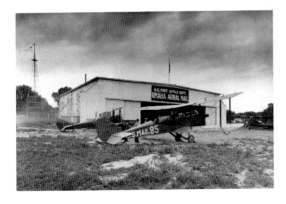

The airmail field at Omaha, Nebraska, 1927. *Smithsonian National Postal Museum.*

Each segment of the transcontinental route had its own set of specific pilot directions. The segments included New York to Bellefonte, Bellefonte to Cleveland, Cleveland to Chicago, Chicago to Omaha, Omaha to Cheyenne, Cheyenne to Salt Lake City, Salt Lake City to Reno and Reno to San Francisco. The following account gives the description of the route from Omaha, Nebraska, to Cheyenne, Wyoming, and from Cheyenne to Salt Lake City, Utah, as published in the 1921 government document:

> Omaha, Nebraska—*The air mail field is on the western outskirts of the city, and is 5 miles west of the Missouri River. The field is rectangular, the long way of the rectangle being east and west. On the north side of the field is a long grand stand facing northward and extending east and west. To the north of the grand stand is a large field with an elliptical race track in it. This race track is an excellent landmark, and the oval may be used for landing if necessary. The west side of the mail field is bounded by a brook, a few trees, and a railroad track. On the south the field is bounded by a paved road which ends to the eastward at the Missouri River. This same road runs due west for several miles beyond the mail field. On the south side of the field are some high trees and a few telephone poles. A private hangar is situated across the road from the air mail field with the word "Airdrome" painted on the roof. The air mail hangar is located in the southeast corner of the field. The east side of the field is bounded by two steel wireless towers and a hill covered with high trees. From the northwest is the best approach, although landings can be made from any direction if made into the wind.*

> The Platte River—[I]*s crossed at right angles by flying due west from the Omaha field. By noting section lines the pilot can determine the correct compass course correcting for drift, as North Platte and Cheyenne are almost due west of Omaha. For a distance of 70 miles the Platte River is north of the course never at a greater distance than 10 miles. The Platte River should be crossed between two bridges, on 2 miles north and the other 2 miles south of the course.*

> Yutan—*Directly on the course 1 mile west of the Platte River, 5 lines of railroads form a junction at this point.*

Wahoo—*A fair-sized town 3 miles south of the course. Six railroads radiate from Wahoo. An excellent emergency landing field is located one-half mile south of Wahoo; a smooth barley field approximately 1 mile long and a quarter of a mile wide. By noting section lines and flying 25 miles west for each mile south, a direct course may be maintained.*

David City—*A quarter of a mile north of the course. Six railroads radiate from this city also.*

Osceola—*Four miles south of the course. The Union Pacific tracks almost parallel the course from David City to Osceola, where they turn to the southward. Osceola may be identified by a mile race track just south of the town.*

The Platte River—[I]*s crossed again and runs southwestward. The Union Pacific Railroad is crossed just beyond the Platte River a half a mile north of the small town of Clarks. Twelve miles southwest is Central City on the Union Pacific Railroad. This city is 7 miles south of the course. Central City is directly east of North Plate. If the pilot passes directly over this city, the east-west sections lines can be followed directly into North Platte. Thirty-five miles southwest of Clarks is Grand Island in a direct line with Central City. Grand Island is 20 miles south of the course. At Grand Island there is a commercial flying field where supplies of oil and gas may be purchased.*

Saint Paul, directly on the course—*Ten miles east of St. Paul one branch of the Chicago, Burlington & Quincy Railroad runs directly west to St. Paul and lies on the course. Five railroads radiate out of St. Paul. The Middle Loup River is crossed 1 mile east of St. Paul.*

Loup City—*Is 5 miles north of the course on the east bank of Middle Loup River, which is crossed almost due south of Loup City. The Union Pacific Railroad paralleling the river is crossed 1 mile east of the river.*

The Chicago, Burlington & Quincy Railroad—[T]*racks following a tiny stream are crossed. The railroad runs northwest-southeast at this point.*

Mason City—*On the Chicago, Burlington & Quincy Railroad; is 2 miles north of the course.*

The Union Pacific Railroad—*[R]unning northeast–southwest, is crossed midway between Lodi and Oconto; Lodi to the north and Oconto to the south. A small creek runs through Oconto which distinguishes it from Lodi.*

North Platte—*After crossing the Union Pacific Railroad no distinguishing landmarks are available, but flying west the Platte River will be seen to the south, gradually getting nearer to the course. The city of North Platte is located at the junction of the north and south branches of the Platte River. The field is located on the east bank of the north branch about 2½ miles east of the town, just 100 yards south of the Lincoln Highway Bridge. Another bridge, the Union Pacific Railroad Bridge, crosses the stream a mile farther north. The field is triangular with the hangar at the apex of the triangle and on the bank of the river. The field, which is bounded on the southwest by the river bank and on the north side by a ditch, has on excellent turf covered surface always in a dry condition. The field is longer east and west and the best approach is from the end away from the hangar. Cross field landings should not be attempted near the hangar, as the field is narrow at this point. The altitude of North Platte is 2,800 feet or about 2,000 feet higher than the Omaha field.*

Ogallala—*The south branch of the Platte River parallels the course to this point and the north branch is only a mile or two north of the course, veering gradually to the northward. The double tracks of the Union Pacific Railroad follow the course to this point. Fly directly west from this point, the south branch of the Platte River and the Union Pacific Railroad, veering to the southward.*

Chappell—*Two miles south of the course on the Union Pacific tracks and on the north bank of the Lodgepole Creek. From here on to Sidney the course lies over the Union Pacific Railroad tracks and Lodgepole Creek.*

Sidney—*The Union Pacific double track runs through here east and west, crossed at right angles by the Chicago, Burlington & Quincy Railroad running north and south. Two miles west of Sidney the Union Pacific double track veers to the north, following the course of the Lodgepole Creek.*

The course, due west, lies from 4 to 6 miles south of the railroad and creek for the next 60 miles.

Kimball—Five miles north of the course on the Union Pacific Railroad and Lodgepole Creek.

Pine Bluff—On the Union Pacific Railroad 2 miles north of the course. The railroad and creek again cross the course, the railroad, turning westward to Cheyenne and the creek, continuing south for 4 miles and then eastward. The country between Sidney and Pine Bluff is the roughest on the whole course from Omaha to Cheyenne, but plenty of emergency fields are found. A ridge extends southward from Pine Bluff, on which numerous dark green trees may be seen. Two miles southwest of Pine Bluff the Union Pacific tracks are crossed and for 5 miles lie south of the course. Then another intersection of the course and the railroad looping to the northward and again crossing the course at the small town of Archer.

Archer—A small town on the Union Pacific Railroad and 8 miles from Cheyenne.

Cheyenne—A white hangar, small white office building, and the wireless towers are on the southwest corner of the field. Field is extensive and the surface is hard. Fly over Ft. Russell and follow the Colorado & Southern tracks to Federal.

Federal—The first town on the Colorado & Southern tracks after it makes a sharp bend to the north. From here almost directly west will be seen black irregular peaks in the Laramie Mountains. Fly over the mountains just to the north of these peaks. This will bring you into the Laramie Valley about due east of Laramie.

Laramie—Is the largest town in the valley. Landing fields abound throughout the valley.

Sheep Mountains—The flat top of these mountains resembles a huddled-up bunch of sheep. A short range about 10 miles long. Pass to the north of the mountains and fly due west over the Medicine Bow Range.

Medicine Bow Range—*Extending north and south. Cross this range at right angles and you come out in the valley of the North Platte River. Landing fields abound throughout this valley. To the west may be seen the Sierra Madre Range. Identified by high white peaks, with the range extending southeast–northwest. Pass to the north of the mountains part of this range where the rounded hills are covered with dense pine forests. From here fly about 70 north of west compass course. You will pass over a rather high and dry plateau cut up by irregular canyons, but with a number of landing fields that can be reached from an 8,000 foot altitude. Continue westward, veering to the north until the tracks of the Union Pacific Railroad are seen to the north. Cross the Union Pacific tracks to the north of Black Buttes, a small town on the Union Pacific, ahead will be seen an irregular butte known as Black Butte. Pass to the north of this and the Aspen Mountains will be seen to the southwest and the Table Mountain Range to the west and a little to the north. The top of Table Mountain Range is almost flat with the exception of Pilot Butte. This is a symmetrical flat top butte on the top of the range. Fly directly toward the Pilot Butte. This will take you over a dry sandy valley across the Union Pacific tracks near Baxter over a low range of hills to the Rock Springs landing field.*

Alternate route from Cheyenne to Rock Springs: Cheyenne to Laramie follow the same directions as above changing course at Laramie.

Laramie—*On the Union Pacific double-tracked railroad. The largest town in the valley. Pass 6 miles to the north of Laramie.*

Rock River—*On the Union Pacific, 20 miles north of the course. The double-tracked Union Pacific passes through 2 miles of snow sheds at this point.*

Elk Mountain—*To the north of the Medicine Bow Range, a black and white range of mountains, the black parts of which are forests and the white snow-covered rocks. Elk Mountain is 12,500 feet high. Fly to the north of this conspicuous mountain over high, rough country. The Union Pacific tracks will be seen about 15 miles to the north gradually converging with the course.*

Walcott—*Cross the S.&E. Railroad 2 miles south of Walcott. The S.&E. joins the Union Pacific at this point.*

Rawlins—*Follow the general direction of the Union Pacific tracks to Rawlins, which is on the Union Pacific tracks. The country between Walcott and Rawlins is fairly level, but covered with sage brush, which makes landings dangerous. Rawlins is on the north side of the Union Pacific tracks at a point about a mile east of where the tracks cut through a low ridge of hills. Large railroad shops distinguish the town. The emergency field provided here lies about 1¼ miles northeast of town at the base of a large hill. Landings are made almost invariably to the west. Surface of field is fairly good, as the sage brush has been removed. Easily identified by this, as the surrounding country is covered with sage brush. Landings can be made in any direction into the wind if care is exercised. Several ranch buildings and two small black shacks on the eastern side of the field help distinguish it. Leaving Rawlins follow the Union Pacific tracks to Creston.*

Creston—*A small station on the Union Pacific is the point where the course crosses the Continental Divide.*

Wamsutter—*On the Union Pacific. Fairly good fields are found between Rawlins and a point 60 miles west. Fields safe to land in show up on account of the absence of sage brush. The course leaves the railroad where the Union Pacific tracks loop to the southeast.*

Black Butte—*A huge black hill of rock south of the course. The Union Pacific Railroad is crossed just before reaching Black Butte.*

Rock Springs—*After passing Black Butte, Pilot Butte will be seen projecting above and forming a part of the Table Mountain Range. This butte is of whitish stone. Head directly toward Pilot Butte and Rock Springs will be passed on the northern side. The field is in the valley at the foot of Pilot Butte about 4 miles from Rock Springs. It is triangular in shape, the hangar being located in the apex. The surface of the field is good. The best approach is from the eastern side.*

Green River—*Follow the Union Pacific double-tracked railroad from Rock Springs. There is an emergency field here which is distinguished account of its being the only cleared space of its size near town. Green*

River is crossed immediately after the city of Green River is passed. Here the course leaves the railroad which continues in a northwesterly direction.

Black Fork River—*A very irregular river, which is crossed at right angles. From Black Fork to Coalville the Union Pacific tracks are from 5 to 20 miles north of the course.*

Granger—*16 miles north of the course on the Union Pacific where the Oregon Short Line joins the Union Pacific from the north.*

Altamont—*On the Union Pacific where the Union Pacific approaches within 6 miles of the course to the north. The railroad passes through a short tunnel at this point.*

Evanston—*After approaching within 6 miles of the course, the railroad turns sharply to the northwest. Evanston is on the Union Pacific 18 miles north of course. There is a good emergency landing field on the southwest side of Evanston, a mile from the railroad station. From Evanston the Union Pacific tracks curve toward the course until Coalville is reached.*

Coalville—*On the single track Union Pacific running north and south. The single track Union Pacific joins the double track 4 miles north of Coalville at Echo City. There is an emergency landing field here a mile east of the railroad and a half mile southeast of town, there is a marker on this field.*

Salt Lake City—*From Coalville the country is extremely rugged and the pilot should maintain at least 11,000 feet altitude above sea level. The field lies 2 miles west of the city, on the northside of the road or street which extends east–west by the Salt Lake fair grounds. Locate the fair grounds, identified by an elliptical race track and large buildings. Follow westward along the road just south of the fair grounds and the field will be reached 1 and ½ miles further on. The field is about one half-mile long north and south and landings are usually made in one of these directions, a landing T is used to indicate the proper place to land. Elevation here is 4400 feet. High-tension wires border all sides of the field except the north.*[17]

The route between Cheyenne and Salt Lake City, especially west of the Laramie Valley, was considered to be one of the most challenging segments

of the transcontinental airway. Pilots were advised to use a map that accurately shows the location of mountain ranges and peaks. Side winds and the inaccuracy of most compasses made pilots state that it is impossible to fly this route with a compass alone. Just west of Cheyenne lay terrain known as "the Hump," where the Laramie and Medicine Bow Mountains rose up rocky and sharp to an elevation of 8,200 feet.

The greatest difficulties of the route were considered to be the wind, storms and clouds. The wind was ferocious, often reaching fifty miles per hour on the ground. Clouds and storms were often bad in the mountains east of Salt Lake, where the route crossed over the forbidding Wasatch Range. Then it was on to the Great Salt Lake Desert, a barren and inhospitable expanse of land where a searing dust storm could sweep across the landscape. East of Elko, Nevada, lay the Ruby Mountains, with jagged snow-clad peaks rising to ten thousand feet. The transcontinental route was demanding in good weather. In bad weather, pilots had to use great skill to carry the mail to its destination.

Radio stations were installed in Omaha, North Platte, Cheyenne, Rock Springs, Salt Lake City and Reno in 1921. Each was separated by about two hundred miles, but pilots were able to communicate with one another and

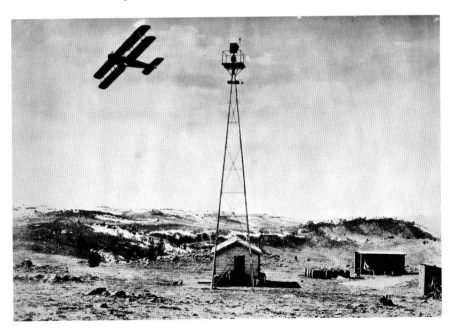

An airmail beacon, Sherman Hill, Wyoming. *Smithsonian National Air and Space Museum.*

with station managers via radio transmissions—if not most of the time then at least some of the time.

Even more pilot skill was necessary when the airmail service was extended to flying at night as well as during daylight hours. In preparation for nighttime flying, a lighted airway had been constructed along the transcontinental route. The airway was illuminated by lighted beacons and floodlights. Construction of each beacon began by erecting a tall beacon tower at a height of about fifty feet, depending on the terrain. Atop the tower was a rotating glass airway beacon either twenty-four or thirty-six inches in diameter. Every ten seconds, this beacon would flash a 5-million-candlepower white light. Beacons without a ready power source would have a small shed at their base housing a generator with nearby fuel tanks. These sheds had specific identifying markings on the metal roof, such as "SL-O 37," meaning that this was the thirty-seventh beacon along the Salt Lake–Omaha leg of the transcontinental airway. The beacon, tower and shed would all sit on a concrete slab foundation with a large concrete arrow positioned at one end pointing the way to the next beacon. The concrete arrows were painted bright yellow and outlined in black so they could be more easily spotted. The beacons and arrows were placed approximately every 25 to 50 miles along the airway route and were pointed from west to east. On a clear night, the beacons could be seen from 40 to 150 miles away, depending on their size and weather conditions.

By 1930, the lighted airway system had become obsolete as radio frequencies became more reliable and sophisticated. However, some portions of the lighted airway system were operated up to the 1960s, and a few airway beacons still survive today.[18]

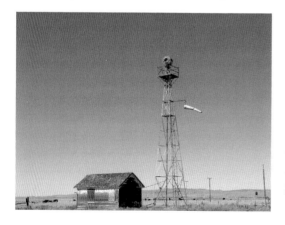

Remains of the tower and office building, still standing at the town airport, Medicine Bow, Wyoming, showing a gusty Wyoming wind blowing the wind sock. *Starley Talbott photo.*

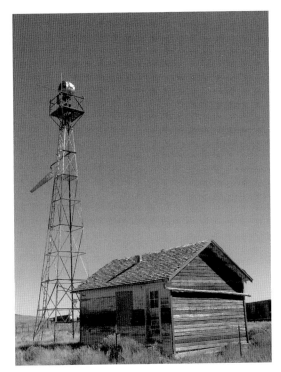

Left: Remains of the tower and office building, still standing at the town airport, Medicine Bow, Wyoming. *Starley Talbott photo.*

Below: Remains of a directional arrow on the transcontinental airmail route in Wyoming. The arrows were painted yellow and outlined in black when in use. Some can still be found on lonely hilltops in Wyoming. *Starley Talbott photo.*

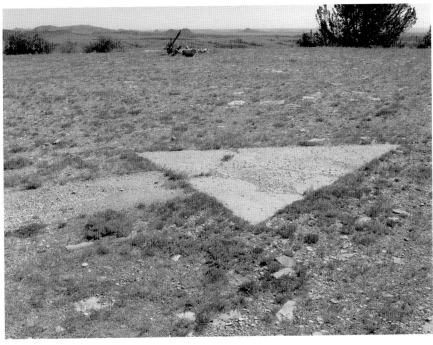

An airfield named "Site 32" was established as an intermediate landing field one mile south of the small town of Medicine Bow, Wyoming, in 1930. When completed, the site included a beacon tower, office building and several other buildings. The small office building was painted white with a wide red stripe around the center of the building. The number "32" was painted on the south side of the roof, and the letters "O" and "SL" were painted on the north side to indicate that this was the thirty-second site on the route from Salt Lake to Omaha. The tower contained a beacon light with a rotating drum and had antennas for radio communication and a wind sock. Edwin M. Cruickshank was the night operator of "Site 32" for many years. He worked from dusk until dawn, turning on the beacon just before sundown and turning it off at sunrise. The prairie grass airfield at Medicine Bow is owned by the Town of Medicine Bow. The beacon tower with the concrete base, the concrete directional arrow and the office building are still in existence, though weather worn. The beacon light is not operational. The landing field is rough and uneven with numerous gopher and badger holes.[19]

Bits and pieces of these early airway markers remain throughout the country. There may be a beacon tower near a modern airport or a concrete arrow on a lonely hilltop or a sage brush-covered prairie out in the middle of nowhere.

Chapter 4

THE WORKHORSE

Just as the Pony Express needed horses to deliver the mail, so the early airmail service needed airplanes to deliver the mail. There were several different planes that were used when the service was first begun, but the two airplanes that were most often used were the Curtiss JH-4 (Jenny) and the de Havilland, model DH-4.

Army pilots flew the Curtiss Jennies on the first airmail trips, including the inaugural routes between Washington, D.C., and New York City, beginning on May 18, 1918. The Jenny was a single-engine biplane that was used during World War I by the U.S. Army Air Service. It was designed by B. Douglas Thomas and had a top speed of 80 miles per hour, with a range of about 175 miles. The Jenny could carry about three hundred pounds of mail per trip. It was not considered very useful by most pilots when flying in bad weather, although one pilot reportedly said that "the carburetor would vibrate the plane so badly that it would shake the ice off the wings."

In June 1918, the Post Office Department took over the airmail service and found that it was in need of more airplanes. The United States Army offered the Post Office Department one hundred surplus World War I de Havilland DH-4 planes, complete with spare parts and extra Liberty engines. These machines, designed as bombers and reconnaissance planes, were not a perfect fit for delivering the mail. However, true to the proverb, "Don't look a gift horse in the mouth," the post office happily accepted the offer.

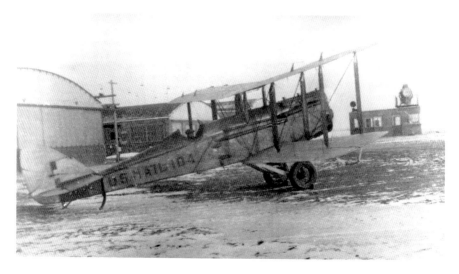

A DH-4 U.S. Post Office airmail plane, Cheyenne, Wyoming. Early on, pilots suffered from exhaust fumes because of short exhaust pipes that were later lengthened to extend beyond the cockpit. *Wyoming State Archives, Department of State Parks and Cultural Resources.*

The DH-4 was designed mainly for short flights at high altitude, not for the long-distance, low-altitude flights that were necessary for mail planes. The DH-4 was originally designed and built as a two-seat bomber. When the post office received the planes, it changed the configuration to make the forward cockpit a compartment for the mail. A major design flaw was that the pilot sat between the engine and the gas tank. In addition, the canvas covering the fuselage was treated with a waterproofing liquid that was extremely flammable. In a crash, the pilot could be easily crushed or burned. The pilots referred to the plane as the "flaming coffin," and they called themselves members of the "suicide club."

Designed in Britain by Geoffrey de Havilland, the planes were first manufactured in Britain. The American production of the DH-4 was begun in 1918 by the Dayton-Wright Company. A total of 4,846 planes was built by Dayton-Wright through the middle of 1919 and remained on duty with the United States Army, the United States Marine Corps, the United States Post Office Department and the Border Patrol until as late as 1932. The American-produced DH-4 was slightly modified from the British model. The American model was powered by a four-hundred-horsepower Liberty 12 engine. It had a wingspan of just over forty-two feet, a length of almost thirty feet, a gross weight of 3,582 pounds, a flight range of 350 miles and a load capacity of five hundred pounds.

This photo demonstrates one of the hidden terrors of flying early aircraft. The "dope" that was used to weatherproof the fabric sides of the DH-4 aircraft was very flammable and could quickly doom an airplane to be consumed in a fireball. *Wyoming State Archives, Department of State Parks and Cultural Resources.*

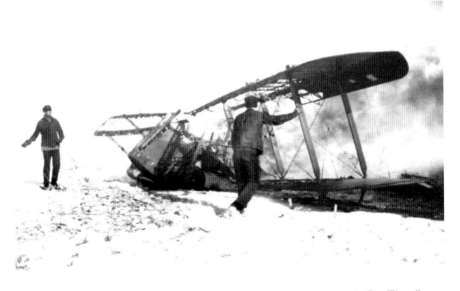

A DH-4 mail plane continues to burn after the plane backfired and caught fire. The pilot, C.V. Pickup, found it hopeless to save his doomed craft on November 28, 1920. *Wyoming State Archives, Department of State Parks and Cultural Resources.*

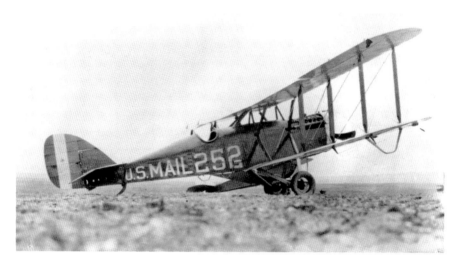

A DH-4 plane in Cheyenne, Wyoming, that has been partially remodeled, showing larger landing wheels and sturdier landing struts than in previous versions of this aircraft. *Wyoming State Archives, Department of State Parks and Cultural Resources.*

Even though the DH-4 was considered a better fit for the post office than the Curtiss Jenny, it continued to cause problems, resulting in many crashes and several deaths. In addition to the rigors of flying long distances and at lower altitudes, pilots were subject to Assistant Postmaster Otto Praeger's so-called "fly or be fired" policy. Pilots felt obligated to operate their rickety, war surplus planes in any type of weather to satisfy Praeger's demands.

In January 1919, the DH-4s were removed from service for extensive remodeling. The renovations included moving the cockpit to the rear of the plane behind the fuel tank and adding padding to cushion the pilot against rough landings. The original linen fabric covering the fuselage was altered so that it was constructed of plywood sheets over wooden struts. The landing gear was repositioned, and larger wheels were installed. In addition, pilots were no longer blinded by their own exhaust fumes when the exhaust pipes were extended beyond the cockpit.

When the newly remodeled de Havillands, called DH-4Bs, were returned to service, they soon became known as the "workhorse" of the airmail service. In 1919, the new DH-4Bs carried more than 775 million letters. By 1921, pilots were assigned individual planes and were allowed to make modifications to their aircraft as they deemed necessary.[20]

Airmail planes were not supposed to carry passengers, and several rules for pilots covered this objective. The rules stated that "pilots shall not carry passengers in mail airplanes except by authority of the Second Assistant Postmaster General or the Superintendent of Operations." Furthermore, "Under no circumstances will the weight of mail be reduced to take on a passenger unless by specific order of the superintendent." In addition, "When proper authority has been granted for passengers to be carried on a mail trip, the representative at the starting point should place his o.k. on the letter authorizing flight, and when the destination is reached by the aviator and passenger, the passenger will then affix his signature on the letter of authorization and the representative will then forward it to the Division of Air Mail Service for the files."[21]

Nevertheless, according to Andy E. Roedel, former Cheyenne resident, author and member of the U.S. Army Air Force in World War I, "If one were well enough acquainted with the pilot and not too much interested in his personal comfort, it was possible to make an occasional trip." Roedel recalled in an article for *Annals of Wyoming* a time when he rode along with the mail: "On a flight to the Pulitzer races in Omaha I perched on top of the

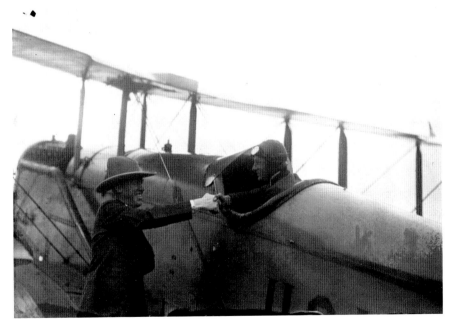

Airmail pilot Hal Collison shaking hands with Cheyenne postmaster William Haas, as Collison prepares to take off on a flight to deliver the mail. *Wyoming State Archives, Department of State Parks and Cultural Resources.*

mail, clinging to a strut, or whatever else was handy, to avoid being bumped off when we ran into rough weather. I arrived at my destination greatly resembling the tar baby, having been right behind a leaky oil pipe all the way down. The first person I met at the races was the division superintendent, who remarked, 'It beats hell how dirty the trains are getting.'"[22]

Eventually, the post office relinquished the airmail service and contracted the service out to private operators. The "workhorse" was replaced by newer aircraft produced by Boeing, Douglas and other aviation manufacturers. But no other aircraft would become as synonymous with early airmail delivery as the de Havilland DH-4. Many of the pilots who flew the airmail's "workhorse" never lost their warm affection for the old plane.

The following chapters tell the stories of airmail pilots who were based in Cheyenne, Wyoming, or were pilots who played a significant part in the establishment of the skyway route that carried the mail across the continent.

Chapter 5

THE FLYING PARSON

The first transcontinental air race in the United States began with sixty-three planes competing in a round-trip contest between New York and California. Forty-eight planes left Long Island, New York, while fifteen planes departed from San Francisco, California, on October 8, 1919.

Lieutenant Belvin Maynard, flying a Havilland DH-4, with a Liberty motor, won the 5,400-mile race across the continent and back. His path to victory was not easy, as he ran into several problems along the round-trip flight, but his background as a test pilot for the army helped him succeed.

Maynard was born in North Carolina and grew up on a farm, where he became an expert mechanic. He aspired to become a preacher and enrolled in Wake Forest College to study the ministry. He was unable to complete his studies there and joined the army in 1917.

Maynard leaned how to fly in the army and spent time testing new planes. After the end of World War I, the young pilot sometimes flew stunts and broke a world record by doing 318 loops in sixty-seven minutes. He competed in an air race from Long Island to Toronto and won by beating some of the world's best pilots.

Newspapers called Maynard the "Flying Parson" because of his time spent studying for the ministry, as well as the fact that he had performed at least one marriage while flying his airplane over Times Square in New York City. He had resumed classes at Wake Forest when he accepted the invitation to participate in the Great Transcontinental Air Race of 1919.

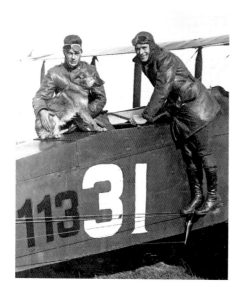

Lieutenant Belvin Maynard climbs into the cockpit of his DH-4 plane. Maynard's mechanic, Sergeant William E. Kline, holds Maynard's dog, Trixie, as they take off for their historic flight to win the Transcontinental Air Reliability Test in 1919. *Smithsonian National Air and Space Museum.*

The morning of October 8 began with much fanfare at Roosevelt Airfield on Long Island, New York. Several planes began the race ahead of Lieutenant Maynard. When he started the engine of his DH-4, his dog, Trixie, ran up to the airplane, barking and jumping. Maynard climbed down, picked up the dog, hopped aboard and left in a roar, with Trixie hanging over the side of the open cockpit.

Maynard reached Chicago by dark, a distance of 810 miles from New York, while his three nearest competitors spent the night in Ohio. Eighteen fliers failed to get beyond Buffalo. On Thursday, October 9, the lieutenant left Chicago at first light. He encountered turbulence near Des Moines and then met and exchanged greetings with the eastbound leader, Captain Lowell Smith, at North Platte, Nebraska. Maynard continued on to Cheyenne, Wyoming, while Smith spent the night in Omaha, Nebraska. The "Flying Parson" ended the day with a lead over Smith of 236 miles.

Frosty overnight temperatures in Cheyenne resulted in an ice-clogged overflow pipe, which, in turn, caused the engine to overheat on starting, damaging the radiator. Maynard's mechanic, Sergeant William E. Kline, made the necessary repairs in five hours, but Maynard was only able to fly to Saldura, Utah, by nightfall. On Saturday, October 11, Maynard and Kline left Saldura at dawn, found ideal weather en route and arrived in San Francisco without incident at 1:12 p.m.

A mandatory rest stop in San Francisco lasted from Sunday, October 12, to Tuesday, October 14. On the return trip to the East Coast, Maynard ran into trouble when a broken crankshaft forced him down forty miles west of Omaha. The young pilot needed a new engine, which under normal circumstances would take several days to acquire. But the resourceful Maynard was able to locate a motor in Omaha and arranged for it to be

trucked to his plane site. Searchlights were set up so the repair crew could work through the night, and they had Maynard's plane ready to fly in eighteen hours. He encountered no further problems after Omaha. The lieutenant, the sergeant and Trixie landed at Roosevelt Field in the early afternoon of October 18, winning the race.

At the victory celebration, Maynard credited his mechanic, Sergeant Kline, good luck and the fact that he had relied on his compass for point-to-point navigation. Maynard then collected his wife, his two daughters and his dog and headed home.

Three years later, on September 7, 1922, Lieutenant Maynard died while stunt flying at a county fair in Rutland, Vermont. He had been performing in a flying circus at the fairgrounds with two other men when the accident occurred. Maynard was performing a tailspin from an altitude of two thousand feet and was unable to pull out of it. The aircraft plunged nose first into a cornfield at the edge of the fairgrounds, killing all three men on board.

Newspapers stated that Lieutenant Maynard was a veteran of World War I but had studied to be a minister before the war. He was a frequent speaker in churches and had been scheduled to give a talk at the Rutland Baptist Church later in the day.[23]

Even though Lieutenant Maynard never became a pilot for the United States Air Mail Service, he played a role in the thrilling transcontinental air race that eventually led to the establishment of a coast-to-coast flight path for the newly minted service. The network of routes, the technology and the experience of these courageous pilots also played a major role in the future development of commercial air service in the United States.

Chapter 6

THE SURVIVOR

The list of men who flew the mail on the western frontier during the 1920s contains some of the best-known names in early aviation. Most of the pilots were colorful characters in their own right, and many had stories of narrow escapes and near-death experiences flying the mail.

Pilots were expected to adhere to codes of conduct:

> *All pilots should conduct themselves as to be in the finest condition both mentally and physically, both for self-protection and for the protection of the valuable property assigned to them. As a pilot in the airmail service, you represent the Post Office Department, and as such a representative you will be courteous, and will act the part of a gentleman at all times. A part of the pilot's rating will be based on the promptness with which he reports for the various duties assigned him. Pilots will obey all orders from the Second Assistant Postmaster General, Superintendent of Operations or Chief of Flying through the division superintendent to whom they are assigned, promptly, or suitable disciplinary action will follow.*[24]

The rules also stated that the most important duty of all pilots was to get the mail to its destination on time. Pilots were informed that on account of the fact that the varying conditions at the various fields prevented drawing up a standard set of field rules, pilots should familiarize themselves with the local field rules at each station. The climate presented the most difficulty in getting the mail to its destination on time.

James P. "Jimmy" Murray flew the first mail plane into Cheyenne on September 8, 1920. When Murray landed in Cheyenne that day, there was no runway. The facility contained a very small wooden hangar surrounded by lots and lots of prairie. Murray recalled that he would fly from daylight to dark on those early flights and put the mail on the train at night. He would fly from Cheyenne to Omaha, deliver mail, turn around and leave Omaha and arrive in North Platte about the time it was getting dark. He would put the mail on a train, and the next morning, he would take a different batch of mail off an early train and fly on to Cheyenne.

If things went well, the flights ended without incidence, but that was often not the case. During those first few weeks in September 1920, several pilots had mishaps along the way. Pilot Stevens, in attempting to land at Rock Springs, misjudged his distance and crossed the corner of the field at a sharp angle, crashing about two hundred feet over in the sagebrush. The radiator of the plane was bent backward and partly torn loose from the engine and the wing damaged to an extent. Pilot Woodward lost his way and passed south of the city of Rock Springs, continuing west for a number of miles. Discovering his mistake, he returned, and the lack of gas made necessary his landing before he reached field. He landed with a crash near the wool warehouse in the north part of town. An examination showed that there was not a drop of gas remaining in the tank.[25]

The weather was often a deterrent to the planes arriving on time at each scheduled stop. Sometimes when a pilot was late getting to the landing field, the postmaster would have to bring the mail out to the airport. Murray told friends that more than once, Cheyenne postmaster Bill Haas trudged out to his plane with the mail sack slung over his back on a cold and breezy day.

At the center of most of the narrow escapes and tragedies was the weather. Fog, wind and blizzards tested the men to the extreme. Blizzards on the route between Cheyenne, Wyoming, and Salt Lake City, Utah, provided some of the most dramatic stories about the hazards the pilots faced.

Jimmy Murray nearly met his end when he was forced to land during a blizzard at Sand Lake in the Snowy Range Mountains of Wyoming on October 20, 1920. When he did not land in Cheyenne at the scheduled time, the airmail service dispatched planes to find him, to no avail.

On the first leg of his flight from Salt Lake City, Murray crossed the Wasatch Mountains successfully and was following the Union Pacific tracks east from Rock Springs. As he neared the Medicine Bow Range east of Rawlins, the peaks were cloud-covered except for the top of Elk Mountain at twelve thousand feet. Murray planned to fly through the gap in the

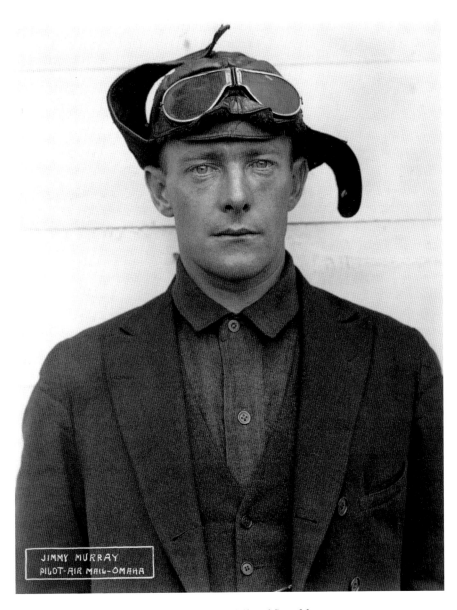

JIMMY MURRAY
PILOT-AIR MAIL-OMAHA

Airmail pilot James Murray. *Smithsonian National Air and Space Museum.*

mountains to the Laramie Valley, but a blinding snowstorm closed around him, and he was unable to see anything. He ended up crashing his plane into treetops near Sand Lake. Uninjured, he was able to spend the night at the lakeshore. The next morning, he walked seventeen miles out of the mountains to Arlington, where he was found.

Searchers and mechanics sent to recover the plane and the mail were able to find their way to the crash site by following the trail left by Murray through the snow. They also reported seeing bear tracks along the trail, making Murray's survival even more remarkable.[26]

Jimmy Murray continued to pilot airmail planes, and on another harrowing flight, he attempted to fly the mail from Sidney, Nebraska, to Cheyenne, a distance of eighty miles. He encountered wind gusts so powerful that they foiled two of Murray's attempts to reach Cheyenne. He finally gave up and landed at Pine Bluffs, Wyoming, some fifty miles east of Cheyenne, having run out of fuel.

Mechanics played a prominent role in the ability of pilots to keep their planes in working condition and often did not receive the attention paid to pilots. Mechanic duties were also dangerous, and several mechanics died during their airmail service. A seventeen-year-old Lawrence Murray came to Cheyenne in 1921 from Norwich, Connecticut, to join his brother pilot Jimmy Murray and another brother, Ed Murray. Lawrence got his first

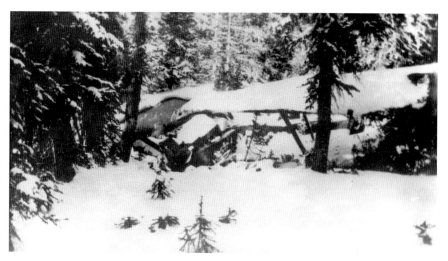

Pilot Jimmy Murray crashed near Sand Lake in the Snowy Range, northwest of Laramie, Wyoming, during a blizzard on October 20, 1920. He spent the night by the lake and then walked seventeen miles to Arlington, Wyoming, to be rescued. *Wyoming State Archives, Department of State Parks and Cultural Resources.*

job in Cheyenne as an apprentice mechanic. He found that everyone who worked at the airport did whatever had to be done. When a plane landed, everybody helped out. Later on, and in addition to his mechanic duties, Lawrence helped install navigation lights along the airway route near Cheyenne for night navigation. He may have helped to install beacons and lights at these markers along the route: Site 32, Salt Lake City–Omaha (SL-O), Medicine Bow, Wyoming; Site 36, Bamforth Lake, SL-O, Albany County, Wyoming; Site 37, Pilot Hill, SL-O, Albany County; Site 38, Hecla, SL-O, Laramie County, Wyoming; Site 40, Silver Crown, SL-O, Laramie County; Site 42, Westedt, SL-O, Laramie County; and Site 43, Hillsdale, SL-O, Laramie County.[27]

Jimmy and Lawrence Murray were part of the pioneer airmail service, one of the most colorful eras in Cheyenne's history, which eventually led to the coast-to-coast commercial airline industry.

After his airmail service career, Jimmy Murray studied law and was admitted to the Wyoming Bar in 1927. He became vice-president of Boeing Aircraft and worked in Washington, D.C., as a lobbyist. He died in 1972.

Chapter 7

HERO OF THE NIGHT

Pilots were the dominant force during the early years of the airmail service. There are many stories of these daredevils of the sky. Most pilots came from military backgrounds and were anxious to be able to keep flying airplanes, so they joined the newly minted service winging the mail across the continent. The airmen were well compensated for their service with an average salary of $3,600 per year, as well as $0.05 to $0.07 for each mile flown.

James H. "Jack" Knight was one of those dashing pilots and was especially adept at flying the route through the Rocky Mountains and beyond. He set a new air speed record, quite by accident, on December 12, 1920, while attempting to reach Salt Lake City from Cheyenne. Knight found himself fighting tremendous winds trying to fly from Cheyenne to Laramie, on the first leg of the flight to Salt Lake City. He decided to turn his plane around after having reached only forty-five miles from his takeoff point in Cheyenne. Due to the ferocity of the gale, he reached Cheyenne only seven minutes later, where his landing was hindered for a further twenty minutes while he side-slipped his aircraft to the ground. It was speculated that Knight had reached a speed of 385 miles per hour. He was exhilarated by his flight and hoped to get permission to fly the eastbound mail to Chicago, thinking he could reach the city in two hours and forty-five minutes. His request was denied.[28]

On another foggy day in Wyoming, Knight crashed his plane into the top of an area named Telephone Canyon, west of Cheyenne and east of

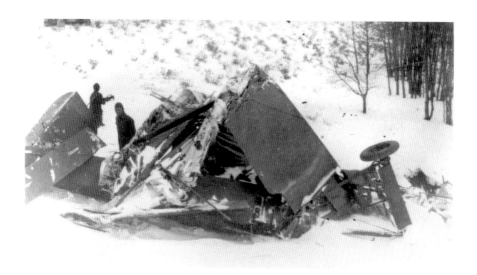

Pilot Jack Knight became lost in fog and crashed in Telephone Canyon, east of Laramie, Wyoming, on February 15, 1921. During the wreck, Knight hit his face on the instrument panel and broke his nose. He then played leapfrog with the mail, the engine and the rest of the plane's wreckage to the canyon bottom. Eight days later, he flew the first transcontinental nighttime airmail flight from North Platte, Nebraska, to Chicago. *Wyoming State Archives, Department of State Parks and Cultural Resources.*

Laramie (today the route of Interstate Highway I-80, from Sherman Hill Summit down the canyon into Laramie). He broke his nose and played "leapfrog" with the plane, engine and mail bags to the bottom of the canyon. Undeterred, he went right back to work, and less than a week later, he became a national hero.[29]

Like many of the pilot's wives living in Cheyenne, Lois Knight talked about being proud of her pilot husband. She recalled in an interview in the May 20, 1921 edition of the *Wyoming State Tribune*, "Jack had to make a forced landing in Telephone Canyon which completely wrecked his ship. It was miles and miles away from anywhere, and it took a long time before he could even get to a telephone to report in. We knew he was down somewhere but that was all. And when he finally got to a phone through the snow, he reported to field officials first, and then he called me. That's the kind of flyer Jack is and he knew that's what I wanted him to do. I certainly am proud to be the wife of a mail pilot. It is wonderful to feel that you are helping, even a little bit, to do something that is making history, just as much as the old time pony express riders made it."[30] Perhaps history had a special role in mind for Jack Knight.

The postal service was constantly trying to improve and obtain money from Congress to keep operating. Since pilots did not fly after dark, the mail was transferred to a railcar to travel during the night. At dawn the next day, a waiting plane would take the mail sacks and fly onward. A train alone needed 108 hours to cross the continent, but the mix of air and rail decreased the time to 78 hours.

Postmaster General Albert Burleson and Second Assistant Postmaster General Otto Praeger devised a plan to demonstrate that airmail could fly across the continent without using the railroad at all. They decided to stage an all-air-cross-country test on February 22, 1921.

Until this time, there had been no nighttime flights for the airmail, as it was deemed difficult for pilots to find their way at night. Airmail pilots relied on visual landmarks such as fields, railroad stations and farm buildings. Pilots often flew as low as fifty feet in snow or fog to see landmarks, and at night, these landmarks disappeared from sight. Praeger envisioned that fires would line the entire transcontinental route to light the way.

Early in the morning on February 22, 1921, two mail planes left Long Island, New York, heading west, while two other planes took off from San Francisco, California, flying east. Relay planes waited at the regularly scheduled stops in between both coasts.

Several pilots flew their portion of the route from west, with Frank Yager landing at North Platte, Nebraska, near 8:00 p.m. that night. When he landed, he cracked the tailskid of his DH-4 plane. Jack Knight was the pilot waiting to take over after the tailskid was repaired.

Knight prepared for the flight not knowing it was to be a very long night. He would have pulled his winter flight suit over his pants, shirt and tie,

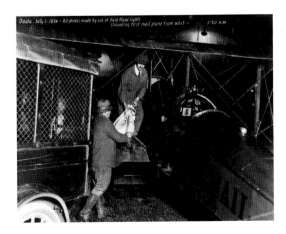

Loading mail onto a plane in Omaha, July 1, 1924. *Smithsonian National Postal Museum.*

61

Pilot Jack Knight showing the type of clothing worn by airmail pilots. Note that Knight is wearing a suit jacket and tie underneath his pilot uniform. *Smithsonian National Air and Space Museum.*

wrapped a silk scarf tightly under the fur-lined collar of the flight suit and pulled on fur-lined boots. He may have placed a leather mask over his face to ward off the wind, added a pair of goggles and then placed a leather helmet on his head. He would have also reviewed his map and taped it to the leg of his flight suit, slipped his flight logbook into his pocket and then pulled

on his fur-lined gloves. He also checked to make sure he carried a toolkit, flares and a parachute. Knight left for Omaha, not knowing that the relief pilot scheduled to meet him in Omaha was stuck in a snowstorm in Chicago. That same storm had also stopped other westbound pilots. Knight was the only pilot left flying, and the future of the airmail depended on him.

As Knight left North Platte, he was able to pick his way through the cold and bitter night by spotting torches and burning oil drums that were lit across the prairie past Lexington, Kearney and Central City in Nebraska. He landed in Omaha at 1:15 a.m. only to learn that he was the only pilot able to fly. Knight had never flown east of Omaha. Undaunted, he drank coffee, stuffed newspapers inside his fur and leather suit for added insulation, studied the route and took off at 2:00 a.m.

Postal workers and farmers had lit bonfires for Knight to follow across Iowa and Illinois. He followed the Rock Island Railroad tracks to Des Moines, Iowa, but couldn't tell the depth of the snow on the field. Instead of landing, he kept on flying east to Iowa City. As he descended toward the field, the night watchman heard his airplane approaching and hurried to light a flare to mark the center of the field. Knight nearly crashed as he set down in the twenty-five-mile-per-hour wind.

The soon-to-be hero of the night was determined to reach Chicago. He rested and warmed himself and then lifted off again at 6:30 a.m. for the final 200 miles. The dauntless and nearly frozen pilot arrived at 8:40 a.m. in Chicago, where the ground crew cut the ice-encrusted flight suit off Knight in order to extract him from his plane. Newspaper reporters were waiting for Knight; his all-night flight covering 830 miles made front-page headlines nationwide.

Although Knight was a hero, the feat was a team victory. The Chicago snowstorm finally cleared, and other pilots took over flying the rest of the route to New York, arriving at 4:50 p.m. on February 23. Seven pilots had taken part in the flight, taking thirty-three hours and twenty minutes to fly 2,629 miles, proving that the mail could be flown totally by air across the continent. Jack Knight had helped bind the continent with his courageous flight.[31]

Shortly after landing, Knight sent a telegram to the post office:

Maywood, Ill Feb 23, 1921, to Praeger, Washington. Left North Platte at ten fifty, cloudy moonshine intermittently from behind broken cloud layer but bad, no particular trouble following course thru use of compass and occasional glimpse of ground and river arrived Omaha 115 am, left 2 am,

delay at Omaha due to studying route Omaha Chicago which I had never flown. Visibility fair until about Des Moines where I encountered fog and snow flurries lasting to Iowa City, lost ten minutes at Iowa City locating town and field and remained there until I got weather report from Chicago as weather was bad. Knight 1145 am.[32]

Later in his career as an airmail pilot, Knight worked with the postal service and local civic leaders to set up a system of navigational beacons and emergency landing strips. He continued to fly the mail even after the system was contracted out in 1925, flying for the Boeing Air Transport Company, which later became United Airlines. Knight continued to work for United and later became vice-president of the company.

Years later, Knight became fatally ill with malaria after traveling to South America while working with the Defense Supply Corps. He had been working to set up a reliable transportation route to the United States for rubber from South America. Jack Knight, hero of the night, died on February 24, 1945, in Chicago, almost exactly twenty-four years after his spectacular flight on a cold and snowy night.

Chapter 8

THE LUCKY ONE

The weather was always the most dangerous part of flying the mail service in those early days on the western frontier. Many pilots lost their lives attempting to cross the continent. In addition to the weather, high altitude and pilot inexperience also contributed to the hazards faced by the early airmail service.

Winter weather often arrived early in the fall in the Rocky Mountains, and snow could come at any time. The October 15, 1920 edition of the *Rock Springs Miner* related that during the week, planes had left for Salt Lake but were compelled to return to the Rock Springs field on account of heavy snowstorms in eastern Utah, making it impossible for them to cross the Wasatch Mountains. On Sunday, October 10, 1920, pilot Buck Hefron had a smash-up about twenty miles southeast of Evanston, and he was ordered to return by train to Omaha for another plane. Chief Mechanic Poetz of Rock Springs was ordered to Evanston to repair the plane and reported that it would be ready for return to Rock Springs in a day or two. Pilot Hefron was in another smash-up later in the week at a point west of Omaha in which the plane was nearly demolished but Hefron was uninjured. Some of these incidents were explained by the fact that the planes had all been adjusted for low altitude, and as a consequence, the landing and taking off at more than a mile in elevation cannot always be correctly timed. In addition, practically all the pilots were inexperienced in landing and hopping off in high altitudes, and their estimates of distances were inaccurate.[33]

Fog, wind and blizzards were the usual culprits. Fog claimed the life of the first airmail pilot in Wyoming when Johnny Woodward slammed his plane into a hill a few miles north of Tie Siding on November 8, 1920.

Hal Collison was another one of the pilots who performed daredevil feats while flying and was known to land his plane in seemingly impossible places. Fog caused pilot Collison to crash his airplane on November 13, 1924. He was flying in a fog bank toward Cheyenne when he found it necessary to make an emergency landing in a tree-shrouded meadow in the Pole Mountain area west of Cheyenne. His choice of a landing area was so small that the plane could not take off again. Airmail service mechanics had to dismantle the aircraft in order to retrieve it. He had been the lucky one that day, though, as he managed to escape unharmed. His supervisor said of Collison, "That so-and-so will fly one of those things down a prairie dog hole some day."[34]

Collison's ability to escape trouble gave him the confidence to face conditions that intimidated others. One December night near Christmas posed another challenge for the airmail service. Pilot Hal Collison displayed his courage when called on to make sure the Christmas mail arrived on time. As Collison waited in Cheyenne for the pilot on a leg from Nebraska, the weather report was ominous. A radio operator at North Platte, Nebraska, reported that the visibility was two hundred yards, it was snowing and the wind was forty miles an hour from the north. The caretaker at the Pine Bluffs office reported that a plane passed overhead at 12:10 a.m. headed for Cheyenne.

The superintendent on duty in Cheyenne thought that perhaps Collison should wait and that the weather was not good for flying. Collison responded, "Wait! Heaven won't have it. We can't hold up the Christmas mails. If I can snake across the Laramie Hills, we're alright. Medicine Bow reports a 500-foot ceiling and Rock Springs is clear." Collison then asked his mechanics to "get his ship warmed up."

The mechanics began the arduous task of starting Collison's airplane in the open, in minus-thirty-degree weather and in the midst of flying snow. The men would often be slipping and sliding across the frozen ground in an attempt to start the engine. Sixteen gallons of boiling water were poured into the radiator, and twelve gallons of heated oil were put in the gas tanks. "Contact!" shouted the mechanic at the throttle. Then, three other mechanics linked hands and lurched forward to pull the propeller into motion. If the engine failed to start after the first few attempts, the water and oil had to be drained before it froze and reheated and the process repeated.

The Cheyenne airmail facility, circa 1924. Note the three "grease monkeys" standing in a daisy chain to help start the motor of the aircraft. The pilot would yell "contact" as he held the starter, and the three men would run to the side as quickly as possible, spinning the propeller and helping to start the plane. *Wyoming State Archives, Department of State Parks and Cultural Resources.*

Meanwhile, Collison dressed for the task at hand. Pilots were fully exposed to the weather when flying in open cockpits, and they wore many layers of clothing. Clothing was made of leather because it was warm for its weight and blocked the wind even when wet. Aviators wore fur collars, leather skullcaps, leather facemasks and goggles. They also carried rags to wipe away the constant spray of oil from the engine.

The pilot bringing the mail from Nebraska landed in the snowstorm in Cheyenne. The mail sacks were transferred to Collison's plane, and he took off with the Christmas mail packed in the front cockpit of his DH-4. He crossed over Sherman summit, where a beacon lit his way toward Laramie, and hugged the Union Pacific Railroad tracks past Rawlins and Rock Springs. Collison scanned the night sky for the flashing lights that lit his way on over the Wasatch Mountains. Just like Santa Claus flying his sleigh through the dark night, he delivered the mail to Salt Lake City in time for Christmas delivery the next day.[35]

As if the weather wasn't enough of a challenge to pilots, a temperamental airplane could cause problems at the worst possible time. Many a pilot found

himself wondering how he had managed to escape unscathed when his airplane began malfunctioning.

Collison found himself in a lucky escape in the Red Desert of Wyoming on another occasion. It brought him a little bit of fame in the January 1926 edition of *National Geographic* in an article by Lieutenant J. Parker Van Zandt, a U.S. Army Air Service pilot:

> *Pilot Collison threw off a propeller blade in the Red Desert one morning near dawn last July, and landed by degrees for a mile or more, tossing away first one propeller blade, then the radiator, then a hasty assortment of cylinders, and finally coming down himself with the remainder of the plane. This accident grieved his heart. Although he had not even blown a tire getting down in the scrubby sagebrush, it was the first time in eighteen "dead-stick" landings that he had broken a wing-skid. "Propellers are my hoodoo" Collison said. "Two years ago, near Elk Mountain, I was flying into a forty-mile wind tossing around in the bumps like a cork in the wake of a steamer. All at once the ship started losing speed and I heard a shrill, piercing sound. Cutting the switches, I made a forced landing on Mike Quealy's ranch, threw out a couple of mail sacks to block the wheels, so the plane wouldn't run away, and started an examination of what was wrong.*

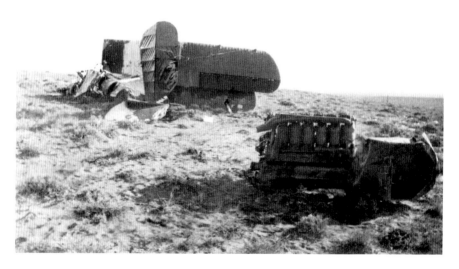

Pilot Hal Collison was uninjured in this plane crash near Rawlins, Wyoming. He seemed invulnerable to wrecks that seemed impossible for anyone to survive. *Wyoming State Archives, Department of State Parks and Cultural Resources.*

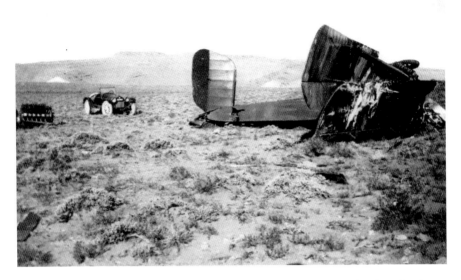

Another view of Hal Collison's wreckage on the prairie near Rawlins, Wyoming, showing his ability to endure. *Wyoming State Archives, Department of State Parks and Cultural Resources.*

You can imagine my surprise when I suddenly noticed that the propeller was completely missing!" "That was number thirteen dead-stick landing," Collison added mournfully.[36]

Hal Collison amassed a record of 3,482 hours and 331,474 miles flown for the United States Air Mail Service. He could count himself as one of the lucky airmail pilots. Following his stint with United States Mail Service, Collison signed on with United Air Lines. He still flew out of Cheyenne and considered himself a native of the city. However, in 1933 he was transferred to Salt Lake City, although he still maintained a home in Cheyenne for his layover residence.

Collison flew hundreds of flights on the route from Salt Lake City to Cheyenne and was known to have carried many passengers both famous and unknown. Sunday, October 6, 1935, was just another trip to Cheyenne. The flight from Reno arrived in Salt Lake City on time, and the crews changed, with Collison becoming the pilot. The Boeing-247 was refueled for the flight to Cheyenne. Just before midnight, the plane left on what should have been a routine flight.

Early morning, October 7, 1935, was calm and warm with good visibility. At 1:44 a.m., a radio transmission came into the Cheyenne station reporting

that Collison had a good flight over Walcott. A half hour later, the copilot reported that the plane was on approach to Cheyenne and functioning well. At 2:17 a.m., the flight was reported to be at 4,400 feet over the Silver Crown beacon ready to glide down for the scheduled Cheyenne landing. Then the plane vanished.

For more than twenty minutes, the Cheyenne operator attempted to reach the United Airlines flight crew. There was only silence. There was no word of the plane, and an alarm was sounded at the Cheyenne terminal. By 3:00 a.m., searchers were engaged in a hunt for the plane, but they found no sign, no fires and no lights on the ground. Finally, at 5:45 a.m., a local rancher saw what appeared to be the rudder of an airplane. A search plane arrived at the scene of the crash and circled overhead to direct officials to the site, ten miles west of Cheyenne.

The area of the accident was in rolling grass–covered terrain, typical of southeastern Wyoming. Pilot Collison evidently was off course, somewhat to the north, but was headed straight for Cheyenne. The course of the

Luck finally ran out for pilot Hal Collison when he crashed his United Airlines plane on a hilltop west of Cheyenne, Wyoming, on October 7, 1935. *Wyoming State Archives, Department of State Parks and Cultural Resources.*

wreckage indicated that there were four distinct collisions with the ground; both motors were torn loose and came to a rest near the bottom of the ridge where the plane had crashed. Twelve people were killed, there were no survivors and the mystery surrounding the crash remains unexplained to this day.

Since Collison was known to be one of the best pilots of his time, one who had a reputation for staying high above the ground so he would always have a way out if something went wrong, it was unexplainable as to why he would crash nose down into the Wyoming prairie. It was found that there appeared to be a firearm among the wreckage that did not belong to the pilot (pilots were allowed to carry guns) and that one of the passengers was a fugitive from justice. Perhaps an incident occurred involving the crew and a passenger, but a subsequent government report on the cause of the crash stated that the accident was probably due to pilot error.[37]

Out on the windswept prairie west of Cheyenne, Wyoming, there are three lonely knolls that forever hold the secrets of a United Airlines plane and the pilot whose luck had finally run out.

Chapter 9

THE UNLUCKY ONES

Pilots who flew for the United States Air Mail Service in the early 1900s were often glamorized and romanticized. These aviation pioneers created the first air routes across the continent, proved that nighttime flying could be accomplished and added to the knowledge that helped aviation roar into the future.

Most airmail pilots navigated by wits alone. They flew in open cockpits where they could lean over the side to spot landmarks in an effort to stay the course. There were no flight maps, and pilots relied on the directions compiled by other pilots and station managers.

This inexact science of early airmail pilots led to many errors, some of which proved fatal. During the first years of the airmail service, there were more than one thousand forced landings, some due to mechanical failure but many due to the weather. Some pilots walked away from an accident with a few bruises, but others were not so lucky. Thirty-two pilots lost their lives during the nine years the United States Post Office operated the service.

Johnny Woodward's airmail service career was only three months old when he flew his de Havilland plane into a snow squall near Tie Siding, forty miles west of Cheyenne, Wyoming. He had left Salt Lake City at 11:30 a.m. and was scheduled to arrive in Cheyenne by 3:00 p.m. Disoriented by the storm, Woodward smashed into the side of a hill and was killed in the crash.

Wind was often the culprit that led to fatal accidents. Wind claimed the first life at the Cheyenne, Wyoming airfield when it dashed pilot Paul Oakes

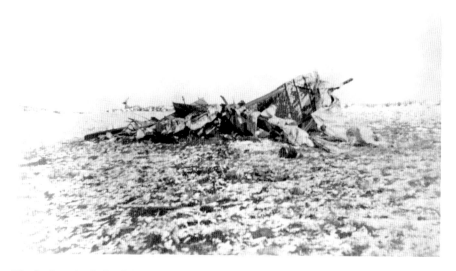

The fatal crash of pilot Johnny Woodward, November 8, 1920. Woodward's airmail service career was only three months old when he hit a snowstorm near Tie Siding, west of Cheyenne, Wyoming, and smashed into the side of a hill. *Wyoming State Archives, Department of State Parks and Cultural Resources.*

to the ground while he attempted to fly aerial stunts for an elderly passenger who was making his first flight, killing both men. Oakes had a reputation for brashness. He was known to fly his plane down Evans Street in Cheyenne below rooftop level in order to fly past the window of his girlfriend's second-floor apartment. The Cheyenne airmail superintendent was said to have hoped fervently that Oakes's girlfriend did not move downstairs.[38] Perhaps pilot Oakes would have lived longer had he paid heed to some of the rules for postal pilots, such as the rule stating that "pilots shall not perform stunts with mail airplanes, nor put them to unnecessary strains in service."

James F. "Dinty" Moore was one of the colorful breed of pilots who flew the mail in and out of the Cheyenne base of operations. He experienced plenty of rough spots during his tenure of service. The Cheyenne division was often plagued by bad weather, and pilots recorded a number of rugged encounters with the elements. Pilot Moore was known as a cautious pilot who followed the rules of the post office, such as the directions for preparing for flight:

> *1. The pilot should inspect his ship thoroughly, reporting any defects to the chief mechanic in sufficient time to permit of corrections before flight is scheduled.*

2. Pilots must be present or in the cockpit when motor is "warmed up."

3. The following rules will be followed in starting the Liberty 12 motor: 1st, Close radiator shutters; 2nd, Retard spark and close throttle; 3rd, Turn on gasoline; 4th, Pump up three pounds pressure; 5th, Prime motor, i.e., turn on gasoline petcock to priming pump, pull plunger out slowly and discharge quickly, three times for cold motor and once only for warm motor; 6th, Close gasoline petcock to priming pump; 7th, Turn motor over four times; 8th, Crank motor with one switch only; 9th, After starting, open throttle slightly and advance spark about half way; 10th, Run motor at 450 to 500 RPM until water is at 40 degrees centigrade and oil pressure about 10 lbs. Then run at 1000 RPM until water is at 60 to 65 degrees and oil pressure about 20 lbs.; 11th, Test ignition through each switch. Determine setting of spark for maximum RPM; 12th, Open the shutters; 13th, Use spark setting determined above for climbing; 14th, Never run motor 1400 RPM on ground longer than necessary to read tachometer for determination of spark setting. Note: Generator reaches voltage at about 750 RPM. Never use two switches below 750. Always use two switches about 750.[39]

Having the mind and skillset to master this complex schedule of preparations could make a pilot successful but offered no help in the face of the random whims of nature. Pilot Moore was eastbound from Cheyenne on March 24, 1922, when he hit a storm near Sidney, Nebraska. He changed course and flew north to Torrington looking for a hole, and he barely made his way back to Cheyenne when his fuel tank was nearly empty. On another flight, Moore landed in Cheyenne and planned to continue onward, but he could not lift off because twelve men were unable to hold his plane on the ground in the eighty-mile-per-hour winds.

On the morning of December 24, 1923, Moore left his wife and four-year-old son at North Platte, Nebraska, for a flight to Cheyenne. He encountered strong headwinds in his single-engine de Havilland biplane as he took off into the westward sky at 7:30 a.m. Residents near Egbert, Wyoming, reportedly heard a plane flying very low on that gusty Wyoming morning. At 8:50 a.m., Moore's plane slammed into a hill two miles west of Egbert. The craft broke in pieces, and Moore was seriously injured.

A Union Pacific Railroad section crew traveling east along the tracks witnessed the crash. They turned their section car around and rushed to the crash site. They found Moore unconscious and pinned in the cockpit. They removed the wings of the plane so they could extricate the injured pilot,

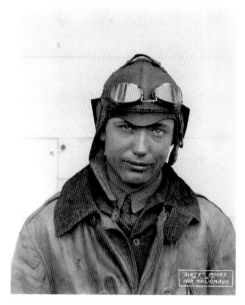

Airmail pilot James "Dinty" Moore.
Smithsonian National Air and Space Museum.

loaded him onto the section car and rushed him to the railroad depot in Burns, Wyoming. It was decided that Moore would be unable to withstand a ride to the Cheyenne hospital on the train, so a Cheyenne surgeon was summoned to Burns for possible treatment of the pilot's injuries.

Moore's fellow mail pilot Frank Yager flew Dr. C.Y. Beard to the Burns hospital where Moore had been transferred. Even though Yager's flight was swift, it was too late, and pilot Moore died at 11:00 a.m., shortly after the surgeon arrived.

Subsequent reports of the tragedy speculated that Moore was flying dangerously low and was unable to lift his plane over the bluff that he crashed into. Additional speculation that his plane was low on gas was proved untrue. A separate plane piloted by Harry Chandler was dispatched to the area to pick up the mail that had been transferred to Egbert. Yager and Chandler flew back to Cheyenne and reported difficulty in bucking the gale-force winds.[40]

James F. "Dinty" Moore was described as one of the most expert and most popular pilots on the airmail flying staff. He is remembered, among others, as one of the unlucky members of the aviation trailblazers.

Chapter 10

THE FLYING FRONTIERSMEN

Even though the post office had run the successful test race in 1921 for continuous flying, including nighttime flying of the mail, no additional nonstop flights were made for three more years. In 1924, the post office established a series of beacon lights every three miles along the route with division terminals. The field at Cheyenne, Wyoming, was fitted with a 500-million-candlepower beacon, and smaller perimeter lanterns were hung on posts situated around the airfield.

On July 1, 1924, Cheyenne pilots Hal Collison, Frank Yager, Harold T. "Slim" Lewis and Harry Chandler flew the first nighttime flights carrying the east- and westbound mail into Cheyenne using the new system. The nonstop flights now meant that it was possible to send mail from either coast to arrive on the opposite side of the continent in an average of thirty-nine hours.

One of these pilots, Slim Lewis, gained quite a reputation for "flying by the seat of his pants," meaning he was able to gauge the plane's performance because the seat was the point of contact between the pilot and the plane. He relied on his own senses to react to his plane and to find his way while flying. He had begun his aviation career in 1916 at age twenty-two and became one of the first licensed pilots in the United States. He was a civilian instructor and test pilot during World War I and hired on with the Unites States Air Mail Service in 1919. Lewis believed that an instrument panel would just clutter up the cockpit and distract the pilot's attention from the railroad or riverbed he was following.

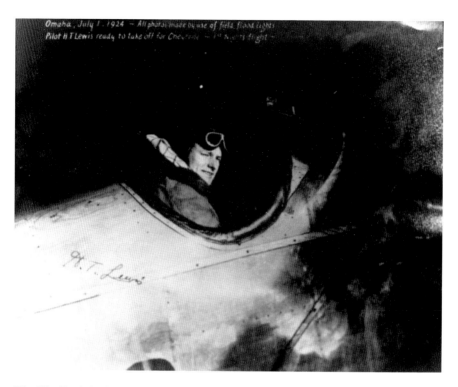

Pilot Slim Lewis in the cockpit of an airmail plane. *Wyoming State Archives, Department of State Parks and Cultural Resources.*

Lewis sometimes landed his plane in odd places, often including ranch and farm lands. One time he rammed his plane into the kitchen of a farmhouse during an emergency landing. He scouted up the necessary manpower to pull the plane out and had another propeller brought in, and he flew the airplane back to the base in Cheyenne. On another night, after several attempts to get off the ground during a howling blizzard, Lewis crashed through a fence at the edge of the Cheyenne Airfield and disappeared into the whirling sky. He was not heard from again until he checked in at North Platte, Nebraska.

Once, when Lewis was flying the run from Scottsbluff, Nebraska, to Cheyenne, the weather was so cold that the carburetor kept icing. Although the distance was only eighty miles, he had to land four times in fields on the frozen prairie east of Cheyenne. Finally, he gave up trying to fly the plane because his hands were so cold. He took the mail sack to a nearby farmhouse, borrowed a team of horses and a wagon and drove the last four miles into the Cheyenne airport.

Because of their frequent forced landings, Lewis and the other pilots had many friends among the ranchers and farmers in southeastern Wyoming and western Nebraska. At Christmas, a mail plane would often buzz the ranch house of friends to alert the family and bring them outside. On the second pass, the pilot would drop gifts that floated to the ground under little homemade parachutes.

On another bad weather day in Wyoming, Lewis performed one of the most expensive emergency landings in airmail history. The fog was so thick that Lewis couldn't see much as he brought down his plane on the Wyoming Hereford Ranch east of Cheyenne. He mistakenly thought he was in an empty pasture, but he happened to set his plane down on one of the prize registered Hereford bulls, killing the animal. When the ranch owners submitted their bill for damages, the post office could not reconcile what they thought was an enormous amount demanded for one animal. A letter was written by a postal department clerk to the Cheyenne superintendent asking if Lewis "had exterminated a whole herd of bulls."[41]

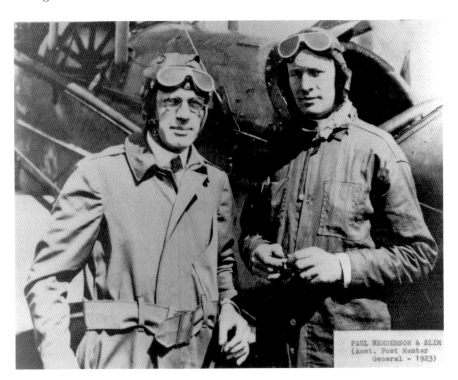

Assistant Postmaster Paul Henderson, *left*, with pilot Slim Lewis. *Wyoming State Archives, Department of State Parks and Cultural Resources.*

Harold Lewis, at six foot, four inches and 185 pounds, earned his nickname, "Slim," honestly and was a legend among the early pilots. In 1926, Slim met Ethel Nimmo, the daughter of pioneer Wyoming ranchers. The couple married on July 21, 1926, and their friends and family dubbed them with the affectionate titles of "Slim" and "Nim."

When the post office ended airmail service on the transcontinental route in 1927 and contracted airmail to private carriers, Slim Lewis signed on with Boeing Air Transport (later United Air Lines), flying a regular run between Cheyenne and Omaha. In 1929, he was made chief pilot of United's Western Division, and in 1934, he was transferred to Oakland, California.[42]

During his tenure as chief pilot for Boeing Air Transport, Slim Lewis had the opportunity to interview Elrey Jeppesen for a position as a contract airmail pilot. Jeppesen happened to be in Reno and learned that Slim was at a local hotel engaging in one of his favorite off-duty activities: playing poker. Wending his way through the smoke-filled room, Jeppesen was able to tell Lewis he wanted to join Boeing and fly the airmail route. Lewis told the young pilot to meet him in Salt Lake City the next day for a flight check. Jepp (as Jeppesen was called) met Lewis early the next morning and climbed into the dual cockpit of a Boeing 40-B mail plane, no. 270, that was used for the flight test. Jeppesen was a fairly inexperienced pilot who had flown a Curtiss Jenny in the past. The Boeing 40-B was slightly larger and heavier than a Jenny and was the preferred airmail plane in the years from 1928 through 1932. Jepposon liked flying the Boeing 40-B, passed the flight test, hired on with Boeing as an airmail pilot and became a favored pilot for Slim Lewis.

Jeppesen lived in Cheyenne for a short time, flying the mail, and was sometimes called on to carry passengers. Once Lewis called him at 10:00 p.m. and asked Jepp to fly two passengers from Rock Springs to Salt Lake City that night. Jepp headed over to Rock Springs, where he related that the Rock Springs airport was down in a ravine with mountains all around and was a challenge to fly into. Jepp made it to Rock Springs, picked up the passengers and flew them to Salt Lake City, finding out that they were none other than Bill Boeing, head of Boeing Air Transport, and Mrs. Boeing.

Later on, Jeppesen signed up for the nighttime mail flights. Because of strong, unpredictable wind currents and weather extremes over the mountains, the Cheyenne route paid the most money: fifty dollars per week plus seven cents per mile (or fourteen cents per mile on the night route). One dark and snowy night, Jepp was flying the mail into Cheyenne when his

motor quit. He was able to set his plane down on a stretch of highway and call the manager of the Cheyenne airport on his primitive radio set. Jepp told the manager he wasn't hurt but that he might freeze during the night. When asked if he knew where he was, Jepp answered that he was 168 miles from Cheyenne. Then, answering the manager's query as to how he knew that fact, he said, "Well, because a sign along the highway where I'm sitting says I'm 168 miles from Cheyenne."[43]

Elrey Jeppesen earned quite a reputation among his fellow pilots by gathering information about landmarks, airfields and other important data that helped pilots to navigate. He purchased a small black ring-binder notebook for ten cents and jotted notes about conditions wherever he flew, including minimum safe altitudes, direction and length of runways, location of the wind sock and the presence of lights and obstacles. He happily shared this information with other pilots until he realized he should probably gain a little money for his trouble, so he had a few copies made and charged ten dollars for a copy of his "little black book."

Jepp married his wife, Nadine, a former stewardess, in 1936, and they lived in Cheyenne for a year before moving to Salt Lake City and then to

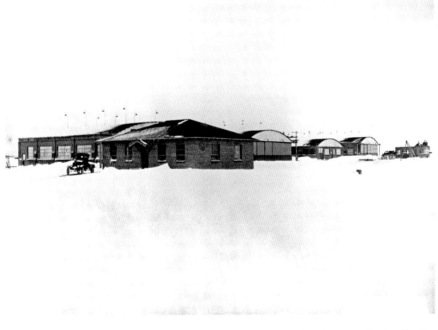

The airmail field on a snowy day in Cheyenne, Wyoming, showing the supervisor's office in the foreground. *Wyoming State Archives, Department of State Parks and Cultural Resources.*

Pilot Slim Lewis sitting on a pole. He may have been participating in a popular fad of the 1920s known as "pole sitting." Or he may have been surveying his beloved Wyoming ranch. *Wyoming State Archives, Department of State Parks and Cultural Resources.*

Denver in 1941. The couple eventually established a business drafting aerial navigation charts that is still in use today. From a ten-cent little black book, the business grew into an international enterprise worth billions. Captain Jepp's statue welcomes visitors to the terminal at Denver International Airport. Slim Lewis had played a part in Jeppeson's amazing career by hiring one of aviation's most celebrated pilots and entrepreneurs.[44]

Lewis resigned from Boeing in 1937 and joined a friend in the formation of Trans-Canada Airlines. He was stationed at Winnipeg, Manitoba, and was in charge of flight personnel. He returned to the position of chief pilot at Boeing in 1939. During World War II, he worked as a test pilot at Boeing.

In 1947, Harold "Slim" and Ethel "Nim" Lewis returned to Cheyenne, where he retired from flying and became a daily visitor to the ranch he had purchased years earlier. In 1939, Lewis had purchased the historic Carey Ranch, twenty-five miles north of Cheyenne, and hired his wife's brother, Bruce Nimmo, to manage the ranch. After moving back to Cheyenne, Lewis drove out from town every day during the spring and summer to look things over and help with the work. It was said that one of his greatest pleasures was to stand on Horse Creek Hill and gaze out over the vast panorama of the rolling hills that encompassed the ranch.[45]

The career of Slim Lewis spanned the skies from open cockpits flying with the airmail service to testing the mighty bombers of World War II. His friends and family said that he was modest, and only when his buddies from the old days of flying the mail came to visit would he ever mention his exploits. Slim Lewis lived the life of a true frontiersman that came to its end when he died on July 25, 1965, at the age of seventy.

Chapter II

OLD RELIABLE

The airmail pilots in the Mountain Division flew mostly reconverted de Havilland planes, model DH-4s, which were both loved and hated by most pilots. The DH-4 model was constructed of wood, covered with fabric and powered by a Liberty motor. They had open cockpits and reached top speeds of about one hundred miles per hour and a ceiling of about ten thousand feet. Flying these planes was especially hazardous on the route crossing the Rocky Mountains.

Drawn by the lure of better than average wages, the love of flying and plenty of excitement, many young men were eager to sign on with the airmail service. They weren't always happy with their flying machines, but they relished the opportunity to elevate aviation to a thrilling new dimension.

Frank Yager was one of those men who saw an opportunity to hone his flying skills and become a part of this new pioneer adventure. He signed on with the airmail service on August 10, 1920, and quickly earned a reputation as one of the top-notch pilots.

On September 18, 1920, Yager set a record by being the first pilot to make the round-trip flight between Cheyenne and Omaha in one day. The feat was accomplished when Yager piloted mail plane no. 75, dubbed as "Old Reliable" by his fellow pilots. This particular plane had recently made four round trips between Cheyenne and Omaha in five days, covering 2,624 miles. The *Cheyenne State Leader* newspaper reported on the outstanding feat performed by Yager, stating that he left Cheyenne at 5:05 a.m. and returned to Cheyenne at 4:55 p.m. The newspaper noted that the pilot "covered the

Airmail pilot Frank Yager. *Wyoming State Archives, Department of State Parks and Cultural Resources.*

full length of the state of Nebraska twice and in addition traversed about 40 miles of Wyoming twice, for a total of 906 air miles." The flight had included a twenty-five-minute stop en route to Omaha at North Platte, Nebraska, to take on oil, gas and water and a twenty-two-minute stop at North Platte on the return trip to Cheyenne.[46]

Yager became known as one of the most knowledgeable pilots within the airmail service. He often was available to offer advice to fellow aviators. Just prior to the establishment of regular nonstop airmail flights, Lieutenant Russell Maughn attempted to set a new record for flying across the continent in a single day. During his 1923 attempt, Maughn's aircraft sprang an oil leak at Sidney, Nebraska. By the time he reached Cheyenne, he was suffering from extreme nausea from the fumes. When he landed at the Cheyenne Airfield, Maughn limped from his plane and lay by the aircraft as mechanics worked feverishly on his engine to stop the leak. After nearly an hour, the mechanics staunched the leak, and Maughn took to the air again in hopes of reaching San Francisco by dark. The next day, news reports stated that Maughn had become overcome by nausea by the time he reached Rock Springs and canceled the rest of his attempt. The following year, in 1924, Maughn landed in Cheyenne on another attempt to set a record. He suffered from a bloody nose because of the high altitude but was able to continue the flight after his plane was refueled. While he waited in Cheyenne, he conferred with pilot Frank Yager about the route ahead while drinking ice water provided by Yager's wife, Fern. Maughn left Cheyenne in the early afternoon and reached San Francisco before dark. This time, he made the flight without incident and credited his success in part to the information given him by Frank Yager.

Yager had his share of excitement in several ensuing flights out of the Cheyenne base. Attempting to fly from Pine Bluffs, Wyoming, to Cheyenne in a blinding snowstorm, Yager proved that he wouldn't let anything stop him. He plowed across thirty-five miles of prairie, skimming along on

the ground and rising into the air several times to graze over a lake, jump telephone wires, hop a fence and barely miss a farmer's windmill.

A few years later, he helped to pioneer nighttime flying of the mail. He took part in the demonstration of the transcontinental day and night service, and he flew the Cheyenne–Omaha route after the night service was established.

On July 7, 1924, Yager left Cheyenne hoping to outrun a storm. By the time he arrived at Lodgepole, Nebraska, he could barely see the lights of the emergency field at Chappell, Nebraska, ten miles ahead. He decided to land at the emergency field, but just as he was landing, a huge gust of wind struck the plane (probably a small tornado). Yager's seat belt snapped, and he was thrown clear of the aircraft, which was totally destroyed; he suffered no major injuries, fortunately.[47]

Forced landings were another issue covered by the government documents spelling out the procedures pilots were to follow per these instructions:

Immediately upon making a forced landing the pilot will put in telephone calls to the two fields nearest him, giving the following information to the field first answering:

1. Place of landing;
2. Time of landing;
3. Reason for landing;
4. Possibility of continuing flight;
5. Possibility of landing another plane nearby and taking off again with the mail.
6. Approximate time mail can be sent by train;
7. Amount of damage, if any, and possibility of flying the plane out with minor repairs.

Despite the fact that a pilot making a forced landing might be injured or disoriented, the post office rules required that the pilot must also stay with the plane and attend to the following tasks:

- *Disposal of mail—reshipment by air or rail in accordance with orders transmitted from the superintendent.*
- *Provisions for guarding the plane against further damage by providing a watchman; moving plane to take advantage of shelter if possible, and tying down to avoid damage from wind; draining of water and oil in cold*

weather; removal of clock, compass, log book and tools to places of safety in case of wreck.

- *If the ship cannot be readily repaired, or is inaccessible, before turning over to watchman:*
- *In cold weather, drain all water by removing plug at bottom of radiator and in pump casting. Turn prop to be sure pump is thoroughly drained. Then replace plugs.*
- *Stake down ship in best manner possible to prevent damage by wind.*
- *Lash controls in neutral position to prevent wind damage.*
- *Disconnect main lead at battery terminal. (Curious visitors cannot then manipulate switch and drain battery, injure generator or start engine).*

To cover watchman's compensation, pilots must carry on every flight "Contract Memorandum" blanks and "Bill for Service Rendered or Material Purchased" blanks, furnished by managers of stations. Pay for watchman is not to exceed 35 cents per hour and for transporting mail from forced landing to railroad station, 25 cents per mile.

The pilot will then proceed to the point to which he is ordered to report, but should not leave the point of landing without specific orders.

The rules went on to state:

It is understood that there will be emergencies in which it will be impracticable to comply fully with the above instructions. In such cases, pilots must use their best judgment and keep in mind these three points:

- *The mail must be forwarded the quickest way possible, preferably by air;*
- *The airplane must be guarded from loss or further damage.*
- *The superintendent must be informed of all the circumstances as soon as possible.*
- *Pilots will be required to turn in written reports of all forced landing upon getting back to their home station. These reports shall give:*
 Place, date and time of landing;
 Cause of landing and results;
 Procedure following the landing;
 Estimate of damage to the plane;
 Estimated damage to property on which the plane landed. Also brief description of damage.[48]

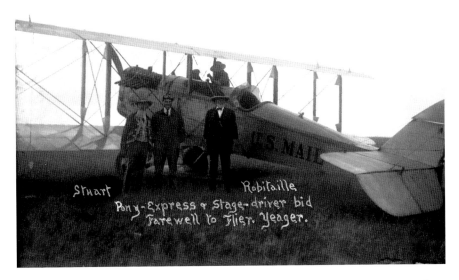

Pony Express rider Jeb Stuart, *left*, and an unidentified stagecoach driver with pilot Frank Yager, *middle*, during the 1926 Cheyenne Frontier Days celebration of the Air Mail and Overland Stage. *Wyoming State Archives, Department of State Parks and Cultural Resources.*

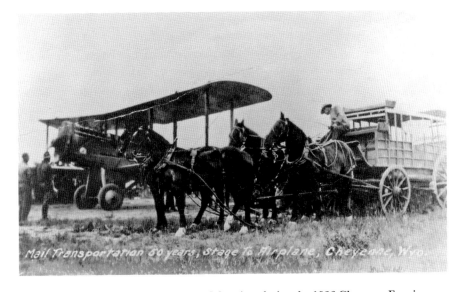

A stagecoach and airplane in Cheyenne, Wyoming, during the 1926 Cheyenne Frontier Days celebration of the Air Mail and Overland Stage. *Wyoming State Archives, Department of State Parks and Cultural Resources.*

Among all these daunting tasks and adventures of the daredevil pilots, friends and relatives awaited their safe arrival back at home in Cheyenne. Yager's wife, Fern, like other pilot's wives, worried about her husband. The airmail pilots were often compared to earlier pioneers who had explored the West.

"I suppose we do feel about the same anxieties and worries that the wives of the early pioneers did," said Mrs. Yager. "Storms or engine trouble might force our pilot husbands down. They might crash against the side of some mountain, or if they land safely they might be attacked by wild animals, or starve, or freeze before help could get through. When Frank doesn't get in on time, only my faith in his ability to handle a ship better than most men keeps me as brave as he would want me to be," she stated in an interview published in the May 20, 1921 issue of the *Wyoming State Tribune*.[49]

From the date of his first appointment with the airmail service on August 10, 1920, to his last flight with the service on June 27, 1927, pilot Yager clocked 4,009 hours and 391,616 miles. After flying for the post office, Yager signed on with Boeing Air Transport, flying its route from San Francisco to Chicago. Yager also tested B-17 and B-29 planes for Boeing during World War II.

At the fiftieth anniversary of the airmail service, Frank Yager, at the age of seventy-seven, recalled the "swashbuckling days he flew for the Post Office both by day and by night." He had flown many miles in many a plane, including one called "Old Reliable."

Chapter 12

THE AIR MAIL ACT OF 1925

As airmail began crossing the country successfully in the 1920s, railroad owners started complaining that this government-sponsored enterprise was cutting into their business. Congressman Clyde Kelly of Pennsylvania, chairman of the House Post Office Committee, agreed with the railroads. Kelly sponsored a bill in 1925 known at the Contract Air Mail Bill. When the bill passed, it also became known as the Kelly Act. The act authorized the postmaster general to contract for domestic airmail service with commercial air carriers. It also set airmail rates and the level of subsidies to be paid to companies that carried the mail.

Additionally, in May 1926, Congress passed the Air Commerce Act. This bill gave the government responsibility for fostering air commerce, establishing airways and aids to air navigation and making and enforcing safety on contract routes.

The Kelly Air Mail Act had a dramatic impact on the routes, such as the one that went through Cheyenne, Wyoming. For two years, the United States Air Mail Service continued to operate as it had always done through Cheyenne. Government pilots in government airplanes still flew the transcontinental route connecting New York and San Francisco. However, the act was clear that all airmail service was eventually to be taken over by private carriers. The transcontinental line was divided into two segments. A call for bids for the private airmail service was conducted, and in January 1927, the post office announced that Boeing Aircraft Corporation had won the contract for the western sector between Chicago and San Francisco.

Boeing took over the western route with headquarters in Cheyenne on July 1, 1927. National Air Transport took over the eastern sector between New York and Chicago on September 1, 1927. All airmail operations were then shifted to private companies flying with their own pilots and aircraft.

The Boeing Corporation found it necessary to obtain pilots, crews and facilities to run the airline. Many of the airmail pilots who flew out of Cheyenne were eager to fly for Boeing, including Slim Lewis, Jack Knight, Hal Collison and others.

When government service was discontinued in Cheyenne, the city took control of the $600,000 in facilities and equipment left behind, including four new hangars built in 1925. The City of Cheyenne then leased these facilities to Boeing Air Transport for a period of four years. The lease was periodically extended between the city and Boeing Air Transport and its successor, United Air Lines. The arrangement continued until the era of commercial operations to fly the mail came to a brief end in 1934. Due to political conflicts, contracts were canceled in favor of the U.S. Army Air

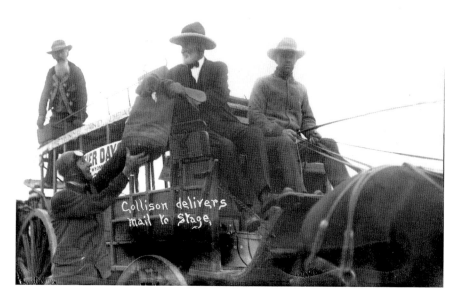

Pilot Hal Collison taking the mail from a stagecoach driver during an airmail celebration during Cheyenne Frontier Days in 1926. *Wyoming State Archives, Department of State Parks and Cultural Resources.*

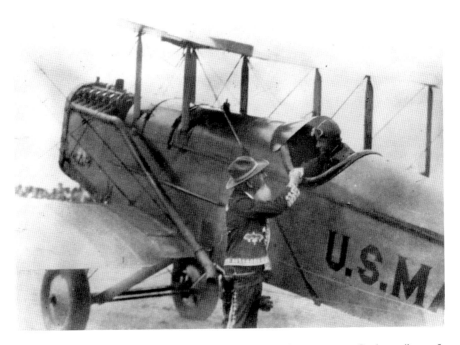

Pony Express rider Jeb Stuart wishes pilot Collison well as he prepares to fly the mail out of Cheyenne, Wyoming. *Wyoming State Archives, Department of State Parks and Cultural Resources.*

Corps taking over the mail service for a very short stint. The lease with United Air Lines was resumed after the brief debacle with the Unites States Army Air Corps ended. The relationship with United and the City of Cheyenne continued until United Air Lines left Cheyenne in 1949.

Many of the airmail pilots who were stationed in Cheyenne continued careers with Boeing, United and other airlines. The frontier spirit that inspired the pioneer pilots to traverse the sky lives on in Cheyenne's tribute to its western heritage during Cheyenne Frontier Days. Some of the festivities have included reenactments of Pony Express riders interacting with the early airmail service pilots.

Chapter 13

THE WINDS OF CHANGE

Many trails of transportation crossed the high plains of Wyoming, from dusty cattle drives to fancy stagecoaches and the silver rails of the Union Pacific. Most are now relegated to the annals of history. Following the era of passenger railway travel, only freight trains wind their way through the capital city of Cheyenne, Wyoming.

There is a common assumption that Denver, Colorado, has always been the dominant center for aviation on the Rocky Mountain Front Range. However, from 1920 to 1945, Cheyenne, Wyoming, clearly dominated all aviation activity in Wyoming, Colorado, western Nebraska, South Dakota and Montana.

Cheyenne sat at the crossroads of transportation history. From its beginning, the small community was something of a thorn in the side of Denver, Colorado, its larger neighbor to the south. Founded to support the first transcontinental railroad, the city of Cheyenne was also on the route for the first transcontinental highway, and at the dawn of commercial aviation, it found itself perfectly placed to be an important part of the first continental airmail and airline routes.

Time and time again, despite Denver's best efforts, Cheyenne seemed to be holding all the cards. For nearly three decades, it was Cheyenne, not the behemoth of Denver, that was queen city of aviation in the Rockies. In a total reversal of today's circumstances, citizens of Denver who wanted to fly anywhere across the country had to catch a connecting flight to Cheyenne or ride the train north. If something had to be shipped as fast as possible,

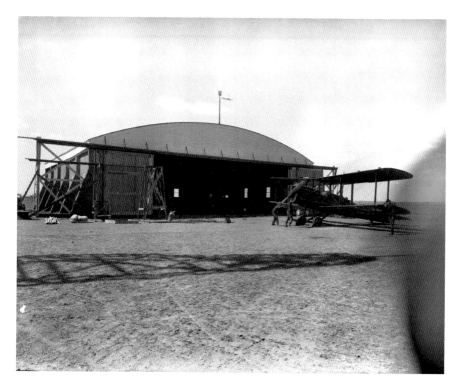

A view of the Cheyenne, Wyoming airfield. *Wyoming State Archives, Department of State Parks and Cultural Resources.*

Cheyenne was where their parcels were sent via airmail. Cheyenne not only played host to the United States Air Mail Service but also later became the principal headquarters of the first large commercial airline in the world, Boeing Air Transport.

The position Cheyenne enjoyed during the first half of the twentieth century was due to its location at the foot of the lowest pass across the Continental Divide in either state at 8,200 feet. The Union Pacific Railroad sought the easiest grade through the Rocky Mountains and found that Cheyenne was the best possible location for a railroad facility. Trains could be serviced in Cheyenne before they began the arduous climb over the area named Sherman Pass, west of the city. Cheyenne was a natural division point for early transcontinental air races because of its location at the base of this pass and with its position on the Union Pacific Railroad. Cheyenne was subsequently chosen as the Mountain Division base of operations for the United States Air Mail Service along the first transcontinental air route

in the world. The railroad provided an easy resupply base and gave pilots a geographic feature they could follow across the continent.

Officials in the city of Cheyenne fought hard to be named the Mountain Division base on the newly established transcontinental airline route that was established in 1920. City fathers voted to donate land for an airfield and provide money to build facilities for the airmail route. When the airmail service was turned over to private contractors in the late 1920s, Cheyenne retained its dominance as an aviation center of the Rocky Mountain region.

A major drama occurred at the Cheyenne Airfield on November 8, 1924, when a fire broke out inside the airmail hangar. With numerous volatile chemicals and gasoline in the hangar, the blaze was out of control in moments. The DH-4s, whose canvas was heavily treated with "dope," a substance that was very waterproof but highly flammable (hence providing the planes the nickname of "flying coffins"), added themselves to the conflagration. The ground crew was helpless to put out the blaze, and the hangar and seven planes were lost. All the local citizens could do was watch the towering black

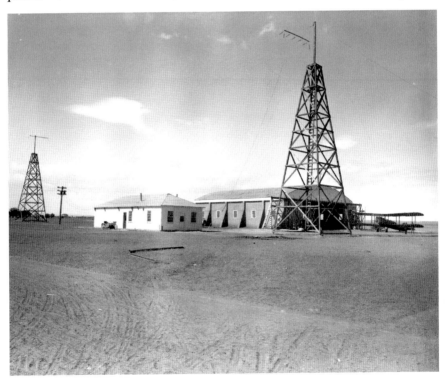

The Cheyenne airmail field, with a radio tower visible. *Wyoming State Archives, Department of State Parks and Cultural Resources.*

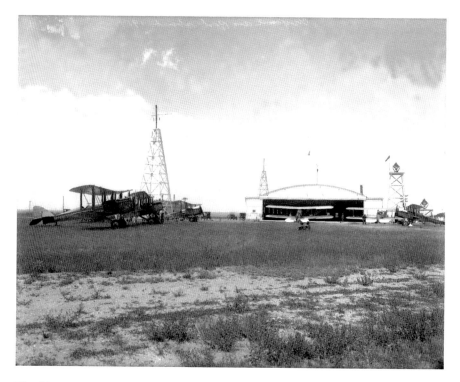

The Cheyenne Airfield, circa 1924. Two young boys sit amid the activity as good weather permits work on the aircraft to be completed outdoors. Note the two signal lights on the right. Cheyenne received its first 500-million-candlepower beacon light in 1924 with the institution of regular nighttime flights. The ground has been worn bare by the landing of airmail planes. *Wyoming State Archives, Department of State Parks and Cultural Resources.*

cloud reach high into the sky as the United States Air Mail Service facility in Cheyenne burned to the ground.

Fortunately, since no one was hurt, the only thing to do was to pick up and carry on. Harry Huking, an airmail pilot who took over the position of superintendent of the Wyoming Division in Cheyenne, replaced the demolished facilities. Instead of one hangar to replace the one lost, Huking conceived of building four smaller hangars to reduce the loss in case of a future fire. In addition to the four new hangars, Huking also commissioned the building of a permanent administration building, a structure that still stands at the Cheyenne Airfield. Wyoming's governor, and the nation's first female governor, Nellie Tayloe Ross, presided at the groundbreaking for the new hangars on July 5, 1925. The new facility was dedicated on December 23, 1925.[50]

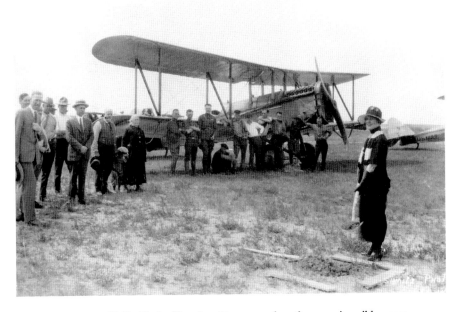

Wyoming governor Nellie Tayloe Ross breaking ground on the new airmail hangars, constructed in 1925. These structures were built to replace the original hangar, which was destroyed when chemicals in the facility and the "dope" on the aircraft caught fire and destroyed the buildings on November 8, 1924. *Wyoming State Archives, Department of State Parks and Cultural Resources.*

In 1925, the U.S. Post Office Department established a contract feeder line to carry airmail south from Cheyenne to Denver and Pueblo. Western Air Express received a contract for the route and began service in 1927. Both mail and passengers were flown on that route. However, if there happened to be too much mail, ticket-holding passengers would be left behind, or passengers might find themselves sitting on mail sacks or carrying mail sacks in their laps.

Beginning in the 1930s, Cheyenne was home to several unique aviation opportunities. Boeing Air Transport established a major overhaul and repair base in the city. The Cheyenne Maintenance Base served as the primary aircraft overhaul facility through the 1930s and until 1946. Boeing Air Transport later merged with other airlines to create United Air Lines. The personnel and pilots of United Air Lines at Cheyenne helped develop significant aviation technologies that became industry standards in the era of piston-engine aircraft.

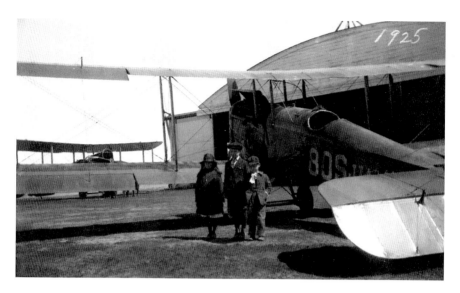

An airmail plane, with three unidentified children posing in front, at the Cheyenne, Wyoming field. *Wyoming State Archives, Department of State Parks and Cultural Resources.*

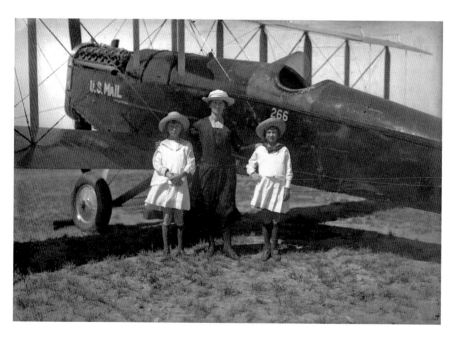

An unidentified woman and two unidentified girls posing in front of a U.S. Post Office mail plane. *Wyoming State Archives, Department of State Parks and Cultural Resources.*

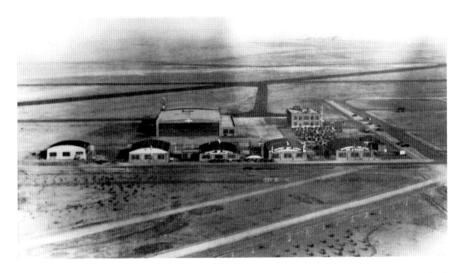

A view of Cheyenne's municipal airport, circa 1930. By this time, Boeing Air Transport had secured the use of the old airmail field and had built a headquarters building and a very large hangar near the original hangars. At this point, Cheyenne's airfield was the largest and most sophisticated in the Rocky Mountain region. *Wyoming State Archives, Department of State Parks and Cultural Resources.*

During World War II, Cheyenne was the location of Modification Center No. 10, the largest such facility in the Rocky Mountain region that upgraded and installed new military technology on nearly half of all Boeing B-17 Flying Fortress Bombers used during the conflict. By the end of the war, nearly three thousand people worked at the Cheyenne Modification Centers, and a total of 5,736 planes had been modified at Cheyenne from September 1942 to July 1945. With the conclusion of the war, the modification center at Cheyenne was no longer needed.[51]

Before World War II, in the early 1930s, Cheyenne also gained a training facility for a new idea for aviation, adding young women to the airline crew as stewardesses. Boeing Air Transport agreed to begin the training school in Cheyenne. The company stipulated that in addition to being capable of performing the job, the candidates had to be unmarried, be no older than twenty-five, be of a height no greater than five feet, four inches tall and weigh no more than 115 pounds. The height and weight requirements were

practical considerations because extra weight on the plane would have a significant effect on performance.

Eight young women arrived in Cheyenne on May 15, 1930, to start four days of intense stewardess training. However, as comes to no surprise to anyone who ever lived in Wyoming, snow arrived shortly afterward; the four-day training period expanded to a two-week snow-in. The training course was later lengthened to five weeks, and more than eighty-three thousand young women came to Cheyenne to complete the course. The stewardess training school for Boeing and later United Air Lines remained in Cheyenne until 1961, when it was moved to Chicago.

Management decisions by United Air Lines ultimately caused the decline of Cheyenne's glorious air age. Larger and newer aircraft could easily traverse the continent and fly over the traditional nemesis, the Rocky Mountains. San Francisco was chosen as the center of United Air Lines' operations because planes could fly nonstop to several locations, including Hawaii. Following World War II, technology advances made it possible to fly from point to point without the need for smaller fueling stops and waystations. Beginning on May 1, 1948, United Air Lines began transferring its Cheyenne Maintenance Base staff to San Francisco, completing the transfer by September 15, 1948.

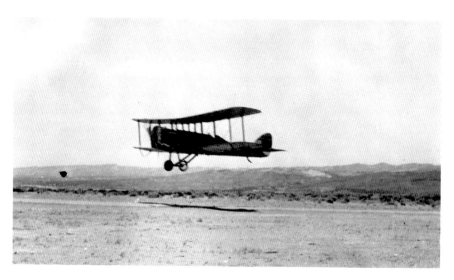

An airmail plane flying across the Red Desert near Rock Springs, Wyoming. *Michael E. Kassel Collection.*

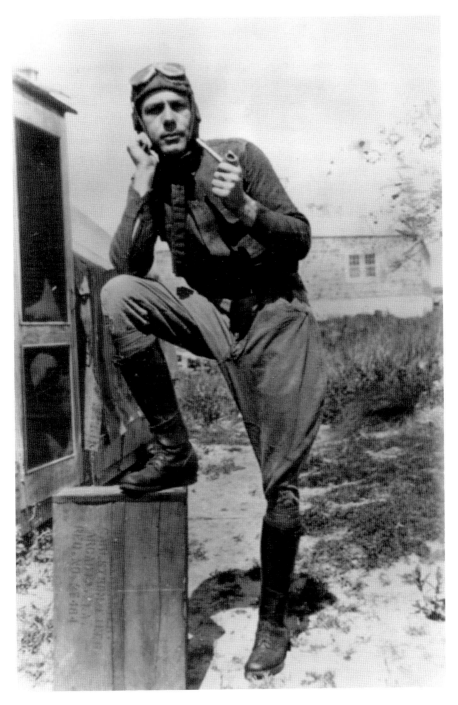

An unidentified pilot posing in the typical uniform of the airmail pilot. *Wyoming State Archives, Department of State Parks and Cultural Resources.*

While several other airlines still came to Cheyenne after 1949, including United, the number of flights never again equaled the activity seen at the city during the previous three decades. The time was now ripe for Denver to claim victory over Cheyenne in the air race. Stapleton Airport had been established in Denver. Eventually, Stapleton Airport was renamed Denver International Airport and relocated several miles east of Denver.

Time, it would seem, had caught up with Cheyenne. In the days of early aviation, the city played a vital role as the base in the middle of North America at the highest point early aircraft could pass over the Continental Divide. With new technology in aircraft, including high cruising altitudes, the mountains became irrelevant, and new planes could easily fly coast to coast without refueling.

There had long been a contest between Cheyenne and Denver, Colorado, for dominance of the airways. Cheyenne won the early rounds, but in the end, even the city's airmail trail lost out to Denver. Denver has one of the busiest airports in the world, while Cheyenne has sprawled out beyond the original airfield that was first established in the 1920s. With no way to expand the present airport, Cheyenne sees only a small fraction of air travel in and out of the capital city. The Wyoming Air National Guard is one of the airport's main tenants at present.

As has been done with the passing of the steam locomotive, Cheyenne's place in aviation history was to be a cradle for a nascent industry that struggled to deal with the immense challenges the roof of the American continent provided. The trail of the airmail was firmly etched on the skies across Wyoming. The pilots of the early mail are among Wyoming's folk heroes adding to the lore of the icons of western history.

NOTES

Chapter 1

1. Leary, "Billy Mitchell and the Great Transcontinental Air Race," 64–76.
2. *Wyoming State Tribune*, "Airplane Race Began Today," October 8, 1919.
3. Ibid., "Interest is Keen," October 9, 1919.
4. Ibid., "Aviator," October 11, 1919.
5. *Denver Post*, "Flying Parson Describes Experiences of Journey Across Nation and Return," October 19, 1919, 2.
6. *Wyoming State Tribune*, "Hungry Hogs Ate Rudder of Airplane," October 13, 1919, 1.
7. Ibid., "Dozen Planes Land Here in Flying Race," October 17, 1919, 1.
8. Ibid., "Warren and Mondell Send Letters by Air," October 17, 1919, 14.

Chapter 2

9. *Wyoming State Tribune*, "Arrangements Complete for Control Point for Aerial Mail," May 9, 1920, 1, 8.
10. *Denver Post*, "First Aerial Mail from East Will Reach Cheyenne Soon," August 1, 1920, 6, sec. 1.
11. *Wyoming State Tribune*, "Larson Monoplanes Reach End of Flight," August 10, 1920, 1.
12. *Rock Springs Miner*, "Rock Springs an Important Stopping Point on the Trans Continental Aerial Mail Route," August 13, 1920, 1.

13. Ibid., "Aerial Mail Planes Arrive on Thursday," August 27, 1920, 1.
14. Roedel, "Wyoming Scrapbook," 64.
15. Adams, "Air Age Comes to Wyoming."
16. C. Wiles Hollock, "The Airplane Mail," *Denver Post*, July 25, 1920, Magazine Section, 1.

Chapter 3

17. Leary, *Pilot's Directions*.
18. Skiles, "Lighted Airway System."
19. Notes from the Medicine Bow Museum and Steve Wolff.

Chapter 4

20. Boyne, *DeHavilland DH-4*.
21. Leary, *Pilot's Directions*.
22. Roedel, "Wyoming Scrapbook."

Chapter 5

23. *Denver Post*, "Flying Parson Describes Experiences of Journey Across Nation and Return," October 19, 1919.

Chapter 6

24. Leary, *Pilot's Directions*.
25. *Rock Springs Miner*, "First Aerial Mail Planes Arrive This Week," September 10, 1920.
26. *Wyoming State Tribune*, "Murray Recalls His Pioneering Airmail Flight to Cheyenne," June 9, 1960.
27. Adams, "Air Age Comes to Wyoming."

Chapter 7

28. *Sheridan Enterprise*, "Air Mail Man Sets Record in High Wind," December 12, 1920.
29. Roedel, "Wyoming Scrapbook."
30. *Wyoming State Tribune*, "When Their Ships Come In," May 20, 1921, 8.
31. Roedel, "Wyoming Scrapbook."
32. National Air and Space Museum Archives.

Chapter 8

33. *Rock Springs Miner*, "Air Mail Service Now on Schedule," October 15, 1920, 1.
34. Roedel, "Wyoming Scrapbook."
35. Van Zandt, "On the Trail of the Air Mail."
36. Ibid.
37. *Wyoming State Tribune*, "Twelve Die When Air Liner Hits Ground 10 Miles West of City," October 7, 1935.

Chapter 9

38. Roedel, "Wyoming Scrapbook."
39. Leary, *Pilot's Directions*.
40. John W. Cornelison, "The Death of Dinty Moore," *Casper Star Tribune*, Annual Wyoming Edition, 1974.

Chapter 10

41. Roedel, "Wyoming Scrapbook."
42. Bernard Kelly, "Slim Lewis, Flying Frontiersman," *Empire Magazine*, *Denver Post*, February 20, 1966.
43. Whitlock and Barnhart, *Capt. Jepp and the Little Black Book*, 108.
44. Ibid.
45. Kelly, "Slim Lewis, Flying Frontiersman."

Chapter 11

46. *Cheyenne State Leader*, "Yeager First Man to Make Trip from Cheyenne to Omaha and Back in One Day," September 19, 1920.
47. Roedel, "Wyoming Scrapbook."
48. Leary, *Pilot's Directions*.
49. *Wyoming State Tribune*, "When Their Ships Come In," May 20, 1921, 8.

Chapter 13

50. *The Magic City of the Plains: Cheyenne 1867–1967*, Cheyenne Centennial Committee.
51. *Wyoming State Tribune*, Cheyenne Frontier Days Special Supplement, July 21, 1942.

BIBLIOGRAPHY

Adams, Gerald M. "The Air Age Comes to Wyoming." *Annals of Wyoming* 52, no. 2 (1980).

Boyne, Walter J. *DeHavilland DH-4: From Flaming Coffin to Living Legend.* Washington, D.C.: Smithsonian Institution Press, 1984.

Hallock, C. Wiles. "The Airplane Mail." *Denver Post*, July 25, 1920.

Kassel, Michael E. "Thunder on High: Cheyenne, Denver and Aviation Supremacy on the Rocky Mountain Front Range." Master's thesis, University of Wyoming, 2007.

Leary, William M. "Billy Mitchell and the Great Transcontinental Air Race of 1919." *Air University Review* 35, no. 4 (May–June 1984).

———. *Pilot's Directions.* Iowa City: University of Iowa Press, 1990.

Roedel, A.E. "Wyoming Scrapbook: The Mail Must Go." *Annals of Wyoming* 17, no. 1 (1942).

Rosenberg, Barry, and Catherine Macaulay. *Mavericks of the Sky: The First Daring Pilots of the U.S. Air Mail.* New York: HarperCollins, 2006.

Skiles, Jeff. "The Lighted Airway System." *Sport Aviation* (July 2016).

Van Zandt, J. Parker, Lieutenant. "On the Trail of the Air Mail." *National Geographic* (January 1926).

Whitlock, Flint, and Terry L. Barnhart. *Capt. Jepp and the Little Black Book.* Brule, WI: Cable Publishing, 2007, 2008.

Websites

Air Mail Pioneers. www.airmailpioneers.org.

DreamSmithPhotos. www.dreamsmithphotos.com.

Mike Newcomer Aviation Art and the Air Mail Research Project. www.airmailart.com.

National Air and Space Museum, Smithsonian. www.airandspace.si.edu.

National Postal Museum, Smithsonian. www.postalmuseum.si.edu.

Wyoming Newspapers. newspapers.wyo.gov.

About the Authors

STARLEY TALBOTT has been a freelance author for more than forty years. She has been published in numerous newspapers and magazines throughout the Rocky Mountain region and is the author of six books, including three Arcadia Publishing titles: *Platte County*, *Fort Laramie* and *Cheyenne Frontier Days*. Starley holds a BS degree from the University of Wyoming and an MS degree from the University of Nevada. She has lived in several states and foreign countries, loves to travel and has a deep appreciation for history. She is a member of Wyoming Writers, Platte County Historical Society and the Wyoming State Historical Society.

MICHAEL E. KASSEL serves as the curator of collections and is the co-director of the Cheyenne Frontier Days Old West Museum. He is an adjunct professor of history at Laramie County Community College in Cheyenne, Wyoming. He holds a BS degree in historic preservation from Southeast Missouri State University, an Associate of the Arts degree in history from Laramie County Community College and a Master of Arts degree from the University of Wyoming. He is the author of *Thunder on High: Cheyenne, Denver and Aviation Supremacy on the Rocky Mountain Front Range* and *The United Air Lines Stewardess School in Cheyenne, Wyoming.*

Visit us at
www.historypress.net
..

This title is also available as an e-book